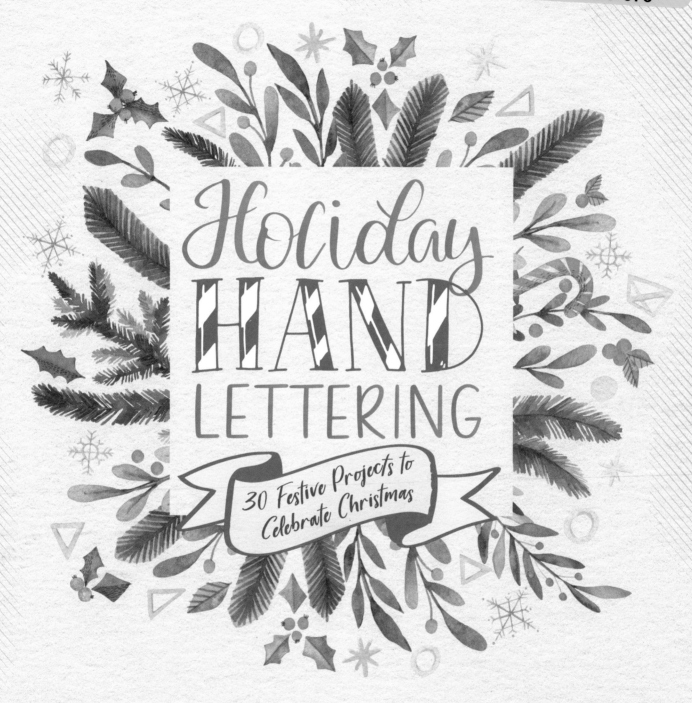

Holiday
HAND
LETTERING

30 Festive Projects to Celebrate Christmas

LARK

New York

New York

An Imprint of Sterling Publishing Co., Inc.
1166 Avenue of the Americas
New York, NY 10036

ISBN 978-1-4547-1103-2

Distributed in Canada by Sterling Publishing Co., Inc.
C/o Canadian Manda Group, 664 Annette Street
Toronto, Ontario M6S 2C8, Canada
Distributed in the United Kingdom by GMC Distribution Services
Castle Place, 166 High Street, Lewes, East Sussex BN7 1XU, England
Distributed in Australia by NewSouth Books
University of New South Wales, Sydney, NSW 2052, Australia

For information about custom editions, special sales, and premium
and corporate purchases, please contact Sterling Special Sales
at 800-805-5489 or specialsales@sterlingpublishing.com.

Manufactured in Singapore

2 4 6 8 10 9 7 5 3

larkcrafts.com
sterlingpublishing.com

Cover design by David Ter-Avanesyan with Sharon Jacobs
Interior design and photo styling by Sharon Jacobs

Photo credits: Christopher Bain: 12, 80, 84, 86, 95, 99, 102, 110, 114;
Getty Images: Daria Dombrovskaya: 6, 8; Alexialex: 76; Jakkapan21: 107 (bg);
Kate Macate/Shutterstock: i, 27; Spot art: Getty Images/iStock; Lena Jacobs: 10

Project Illustrations by: Marie Hermansson: 47–49, 57–58, 65–67, 121;
Shelly Kim: 18–19, 82–83, 88–92, 100–101, 108–109, 118, 123;
Hazel Nguyen: 14–17, 22–23, 50–51, 79, 85, 116, 120;
Veronica Ruiz: 20–21, 38–39, 53–55, 97, 104–105, 112, 117, 125;
Colleen Wilcox: 31–32, 42–45, 60–63, 69–75, 122, 124;
Winterbird: 25–27, 29–30, 34–37, 119

CONTENTS

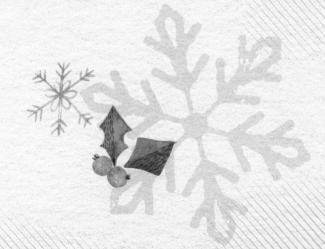

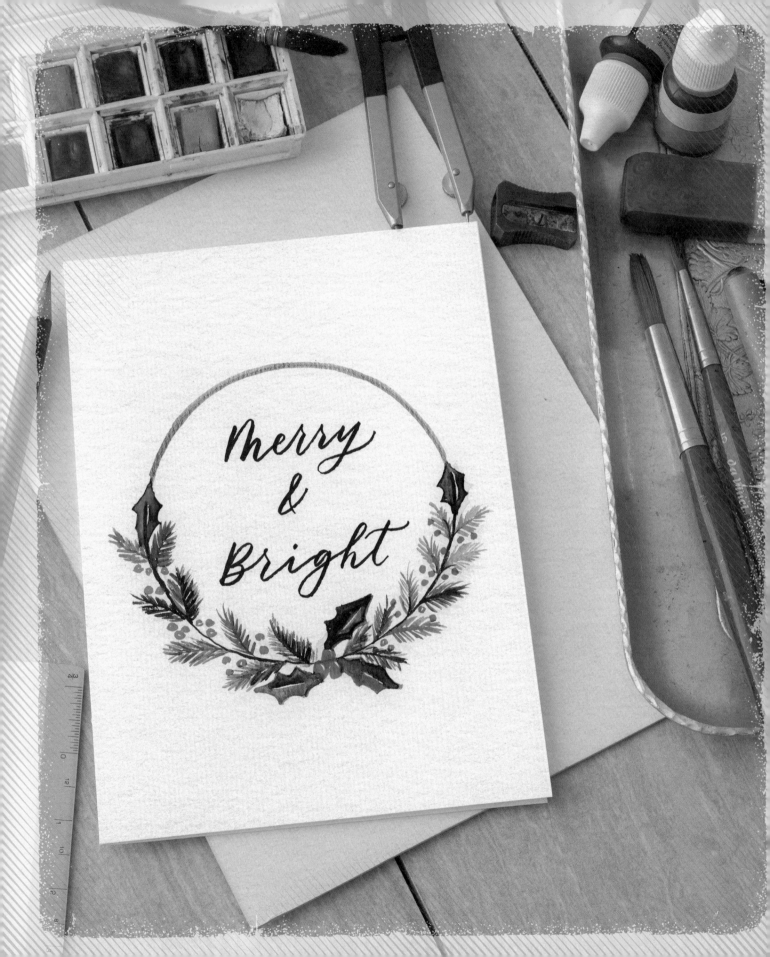

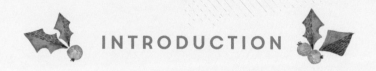

INTRODUCTION

There's no better time than Christmas to take a deep dive into hand lettering. There are greeting cards to send, ornaments to hang, halls to deck, and gifts to wrap. From fabric to card stock, the places where hand lettering can make an appearance are truly endless. The holiday season offers plenty of opportunities to learn and experiment with this infinitely adaptable art form.

Although it's easier to pick up a box of printed cards or decorations, hand-lettered artwork adds a personal and meaningful touch that is sure to delight a gift recipient or charm guests arriving for a Christmas party. The act of hand lettering itself serves as a well-deserved break from the hustle and bustle of holiday preparations, gift shopping, and family gatherings. Plus, drawing and crafting with hand lettering is an excellent excuse to stay indoors when the weather looks especially frightful. What could be cozier than spending an afternoon in your pajamas, sipping a mug of hot cocoa, and making something beautiful?

With this spirit in mind, the six artists featured in this book present a collection of thirty projects, plus ten hand-drawn alphabets, that offer ideas for celebrating the season with lettering. Some projects offer the chance to practice specific techniques or try a design approach, while others will encourage you to experiment with new materials and writing utensils.

The projects are divided into two sections. The ideas featured in **Projects on Paper** are perfect for greeting cards, wall art, or your personal sketchbook. The **Projects Off the Page** section features fun holiday crafts that offer inspiring ideas for incorporating hand lettering into home décor items. In each section, the projects are arranged by their degree of complexity—if you're a hand-lettering beginner or pressed for time, the pieces at the beginning of each section offer elegant designs that will have you creating beautiful letters in no time.

If you're looking for something more challenging, head to the end of the section, where you'll find festive ideas for arranging words into shapes or incorporating illustrations into your creations. Along with instructions for each project, you'll also find practice space that you can use to re-create a piece, sketch a design to trace, or draw your own version. Use the featured designs as a creative springboard—try mixing and matching the elements from your favorite ones, or create something entirely new.

Whether you're making a special card for a loved one or looking for something new to hang on the Christmas tree, this book is here to spark your creativity and offer you a space to explore. Inspiration for your next hand-lettering project is just a few page flips away.

THE BASICS

Part of the beauty of hand-lettering is its simplicity and accessibility. If you're completely new to hand lettering or need a refresher, it's easy to get up to speed on the supplies and terms you need to know. Just read on!

HAND-LETTERING TOOL KIT

The supplies listed below have been chosen specifically to help you re-create the pieces featured in this book. You can easily find each item at your favorite big box, craft, or art supply store, and perhaps you already have some of these items at home.

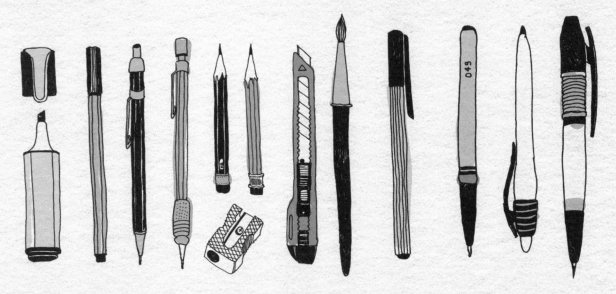

BRUSH PENS

Brush pens have tips that mimic the range of motion of traditional brushes and come in a range of sizes. These versatile writing tools will help you create both thin and broad strokes.

CARD STOCK

Sturdier than printer paper and easy to fold, card stock is an excellent option if you're planning to use the designs in this book to create greeting cards or wall art. Card stock comes in different weights, measured by pounds (or grams per square meter, if you use the metric system).

CHALK MARKERS

Chalk markers contain a pigment-based ink made from traditional chalk and alcohol. Compared to traditional chalk, these markers leave brighter, more opaque swaths of color that pop off a dark background. Once the ink dries, your design will be less prone to smudging and fading.

If you're using your chalk markers on a nonporous surface, such as glass or plastic, you can erase the ink using a damp paper towel. For porous surfaces, it might be tougher to do the same. If you're unsure about your surface, test how your ink reacts to it in an inconspicuous area.

CHALK PENCILS

Chalk pencils look like regular pencils but dispense chalk instead of graphite. They are an excellent tool for sketching if you're creating a design that features white hand lettering against a colored background.

COLORED PENCILS & MARKERS

When it comes to experimenting with color, these familiar art supplies are essential. For markers, it's helpful to have several tips in different widths on hand. Fine tips will make outlining and detail work a breeze, while a thicker tip will help you color large areas.

DRAWING COMPASS

You might remember this tool from geometry class. Here, you'll be using it to draw perfect curves and circles.

FINE LINE DRAWING PENS

Fine line drawing pens, also known as fineliners, work well for precise line work and will help you create neat, even letters. Their plastic needlelike tips come in a variety of widths.

GEL PENS

Made with water-based gel inks, these pens create vivid, bold lines in a wide range of colors. You can even find gel pens with metallic and glittery ink, which can add an extra-festive touch to a finished piece.

PAINT PENS AND MARKERS

Want the bold color of paint and the precision and control of a marker? Then paint pens and markers are your best bet. The ink from paint pens works well on many different surfaces, from paper to ceramic, but keep in mind that some formulas can take a little longer to dry than your average marker ink.

PENCIL AND ERASER

For nearly every project in this book, you'll need a pencil to sketch out your piece and an eraser to refine your preliminary drawings and fix mistakes. Both mechanical pencils and old-fashioned ones work equally well.

RULER

Take the guesswork out of drawing straight lines and keep a ruler by your side. For these projects, a 12-inch (30.5 cm) ruler will serve you well.

TRACING PAPER

Tracing paper will help you copy any hand-lettering design down to its finest strokes and details.

WATERCOLOR PAINT & BRUSHES

Interested in trying brush lettering with paint? Watercolor is a versatile medium that gives you the option to create your own custom color palettes. A twelve-color set will be more than enough to get started. As for your brushes, all you'll need in the beginning are a handful of round brushes in a few different sizes. You can also try using a water brush pen, a pen-like tool with a reservoir designed to hold water and dispense it through its brushlike tip.

WATERCOLOR PAPER

If you're using watercolor as a medium for your hand lettering, it will be handy to have a pad of watercolor paper on hand for experimentation. Watercolor paper is designed to withstand the moisture from your paints without significant wrinkling, warping, or bleeding.

USING TRACING PAPER

If you find a design that you particularly like and want to copy it exactly, you can use tracing paper to transfer the design in the book to your project. You can also use tracing paper as a way to practice drawing letters in a specific style. If you're new to using tracing paper, here's a quick guide.

1. Lay a sheet of tracing paper over your desired design. If you're worried about the tracing paper moving around as you draw, use some tape to secure the corners.

2. Using a pencil, trace the design onto the tracing paper.

3. Once you're satisfied with your drawing, remove your tracing paper and turn it over. Rub pencil lead on the back side of the paper until the area with your drawing is covered.

4. Place the tracing paper on the paper to which you're transferring your drawing, back side facing down. Retrace the design on your tracing paper. When you remove your tracing paper, you should see the outline transferred onto the new paper.

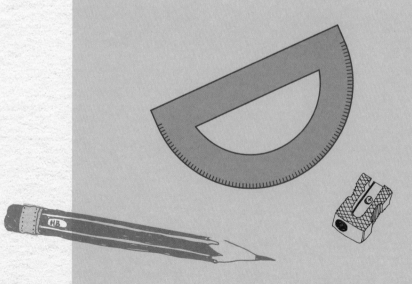

TIPS AND TRICKS FOR DIY CARDS

When it comes to making your own greeting cards, preparing the paper that you're using is just as important as creating the design on the front of the card. Many craft or stationery stores sell ready-to-use blank cards in a range of sizes, offering a convenient option if you have a long of list of recipients or don't want to worry about cutting paper or card stock to a specific size. If you are interested in the DIY route, here are a few tips for making professional looking cards.

❋ **Have a ruler at the ready.** A ruler is indispensable for measuring sheets of card stock and for dividing your sheets into individual cards using simple pencil guidelines.

❋ **Paper cutters can come to the rescue.** If you're planning to make a large number of handmade cards or wall art, it might be worth investing in a paper cutter, which will ensure straight lines and consistent sizing.

❋ **Score your card stock before folding it.** Scoring, which involves making a crease or indentation in your paper, will help you make clean, smooth folds and is especially useful if you're using thick card stock. All you need to do is align a ruler along the line that you want to fold and trace the edge of the ruler with your scoring tool. You can use a bone folder orthe blunt tip of any object (such as a butter knife).

❋ **Consider making postcards.** Keep your crafternoons simple by making postcards instead. All you have to do is add your design to the front of the card and then you can call it a day.

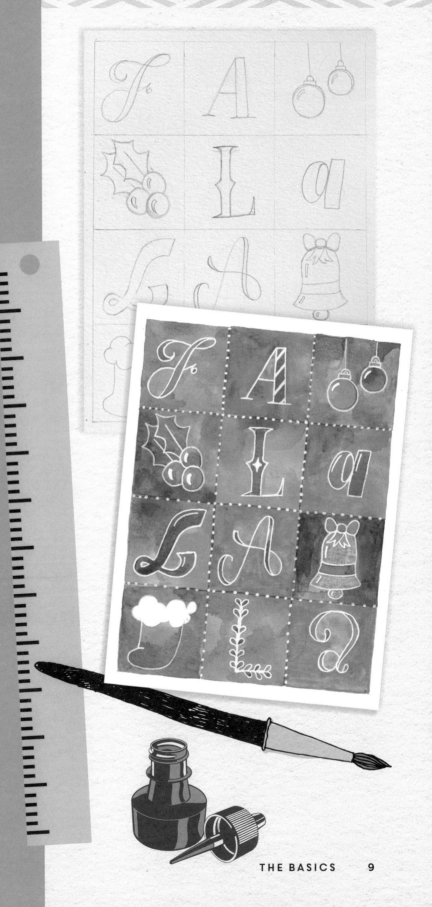

CRAFTING SUPPLIES

In addition to hand-lettering supplies, you'll need a few other items to make some of the pieces featured in the **Projects Off the Page** section (pages 77–114). As with the tools and materials that you'll find in your hand-lettering toolkit, these items are easy to source at any store that sells craft and art supplies.

CHALKBOARD PAINT
Chalkboard paint is specially formulated to turn any object or wall into a chalkboard. Once it dries, it leaves behind a hard and durable surface that is perfect for your chalk lettering needs.

LIGHT BOX
Used to facilitate drawing and tracing, a light box is a device with a translucent surface placed above a light. When you place a sheet of paper on the surface and turn on the light, you'll be able to see through it. A light box is a worthy investment if you find yourself tracing many different items, but if you're looking for an alternative, you can tape your paper to a window to achieve the same effect or use tracing paper (See **Using Tracing Paper**, page 8).

RIBBON & TWINE
You'll make some projects that you'll want to hang up or that involve components that need to be strung together. Ribbon will add an elegant final touch to a Christmas ornament or a banner, while twine will give your finished piece a rustic look. Ribbon comes in many colors, patterns, and widths. For the projects in this book, ribbon with a width between ½ and ¾ inch (1.3 and 2 cm) will work well.

SCISSORS
A sturdy pair of scissors is indispensible for cutting out your hand-lettered pieces from larger pieces of paper.

HAND-LETTERING TERMINOLOGY

If you're new to hand lettering, you might come across some unfamiliar terms. Put the head scratching to rest with this handy reference.

BASELINE This term refers to a horizontal line on which most of your letters sit. Some letters, such as a lowercase *g* or *y* have sections that fall below the baseline.

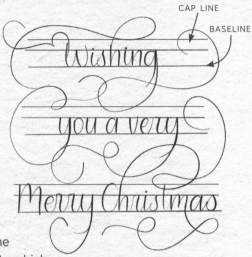

CAP LINE

BASELINE

CAP LINE The cap line indicates the extent to which capital letters fall above the baseline and denotes the height of the capital letters.

DOWNSTROKE A downstroke is any line that you create when you move your writing utensil in a downward direction. In most cases, you'll make downstrokes by applying more pressure as you draw.

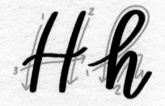

INLINE The inline refers to the area inside the outline of your letter.

LETTERFORM The word *letterform* simply refers to the shape of your letter.

MONOLINE A monoline letter is one where all the strokes have the same weight.

POSITIVE SPACE & NEGATIVE SPACE
In a piece of artwork, positive space refers to the elements that are the focus or subject of the image, while negative space refers to the space around these elements.

POSITIVE SPACE

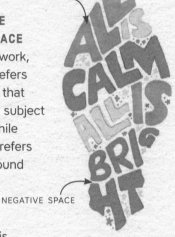

NEGATIVE SPACE

SANS SERIF This adjective is used to describe letters without any additional strokes attached to the end of their strokes.(See *Serif*.)

SERIF Have you ever noticed that certain fonts have letters with very small lines and marks that appear at their tops and bottoms? These marks are known as *serifs*.

UPSTROKE An upstroke is any mark that you make when you move your writing utensil upwards. You'll want to use lighter pressure when creating an upstroke.

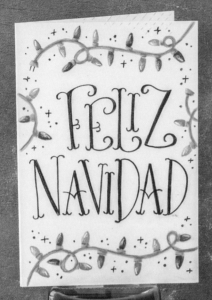

FELIZ NAVIDAD

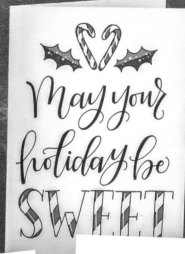

May your holiday be SWEET

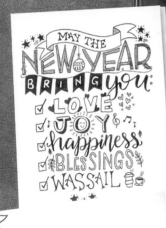

MAY THE NEW YEAR BRING YOU:
✓ LOVE
✓ JOY &
✓ happiness
✓ BLESSINGS
✓ WASSAIL

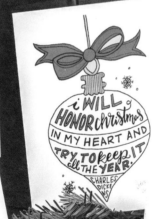

I WILL HONOR christmas IN MY HEART AND TRY TO KEEP IT all THE YEAR
—CHARLES DICKENS

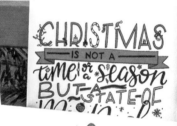

CHRISTMAS IS NOT A time or a SEASON BUT A STATE OF MIND

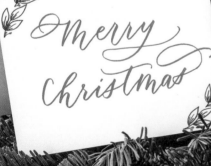

Merry Christmas

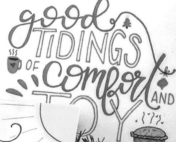

good TIDINGS of COMFORT AND JOY

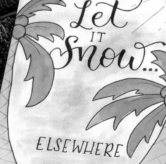

Let it Snow... ELSEWHERE

PROJECTS
ON PAPER

Season's Greetings

By Hazel Nguyen

This simple, fun design features a vintage-looking banner and a white-and-black color scheme. If you have always wanted to add banners to your designs, but don't know how, this project is for you.

WHAT YOU'LL NEED:

- Pencil and eraser
- Card stock
- Black fine-tip brush pen

WHAT YOU'LL DO:

1. Use your pencil to draw your banner onto the center of your card stock. If you're new to banner drawing, flip to page 16 to learn how!

2. Sketch out *Season's* above the banner and *Greetings* inside the banner in script.

3. Once you are happy with your sketch, trace your design with the fine-tip brush pen {A}. If you want to give it more personality, add the rays around the banner as shown {B}.

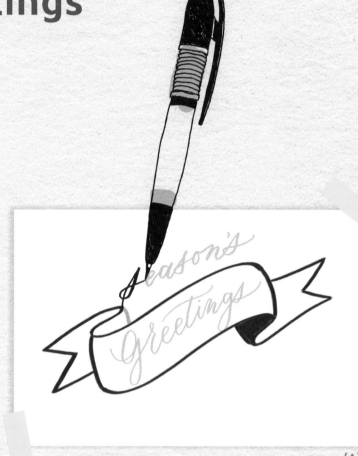

{A}

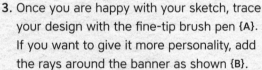

{B}

PRACTICE

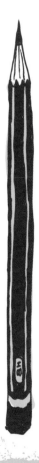

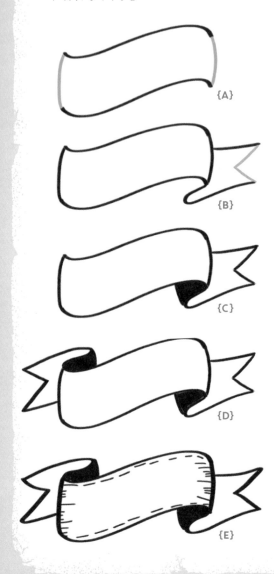

{A}

{B}

{C}

{D}

{E}

DRAWING BANNERS

Banners are one of my favorite things to draw! They create statements and emphasize the parts of your design that you want to highlight. Here's a simple step-by-step guide on how to draw this wavy banner. *Use the space above for practice.*

1. Draw two wavy parallel lines for the top and bottom of your banner. Connect the parallel lines to create a wavy rectangle {A}.

2. To create a fold in your banner, add an s-shaped tail on the bottom right. Draw a line above the line you just created, then draw a *v* at the end of the two lines you've drawn in this step {B}.

3. Draw a line from the s-shaped tail to the main rectangle. Then color in the space {C}.

PRACTICE

4. For a fold in the other side of your banner, add an s-shaped tail on the top left of the rectangle. Draw a line below the line you just created, then draw a *v* at the end of the two lines. Repeat step 3 to finish the fold {D}.

5. For a vintage look, add a stitch-like pattern along the top and bottom edges of the rectangle. On the side edges, draw short horizontal lines. As you draw lines down the length of a side edge, vary their length, adding a few short lines at first before drawing a longer single line {E}. Don't worry about making them perfect. Some imperfections give your piece more personality.

Let It Snow

By Shelly Kim

This project features a fun design that works well for a large poster. Use it to decorate for holiday parties and office parties, or hang it as home décor for the holiday season!

WHAT YOU'LL NEED:

- Pencil and eraser
- Ruler
- Brush pens in colors of your choice
- Large poster board

WHAT YOU'LL DO:

1. Using your pencil and ruler, draw four evenly spaced horizontal lines to create lettering guidelines. In between the second and third lines, draw two parallel, wavy lines for a banner, and hand-letter the word *it* in capital letters using a non-script font {A}.

2. Using the guidelines, lightly hand-letter the words *let* and *snow* in a script font with pencil to sketch the design {B}.

3. Add a few light sketches of snowflakes around the poster board using pencil {C}.

4. Using a brush pen, draw over the sketched words and the banner {D}. Using a brush pen in another color, draw over the snowflakes. If you're using a lighter colored brush pen, erase the pencil marks after lettering with brush pens.

5. To add a finishing touch, add some outlines along the words *let* and *snow* for the downstrokes. Note: the outlines do not need to be drawn in a specific order. If you like, you can add an outline stroke for every downstroke of each letter at the very top of the letter. Erase any pencil sketch marks.

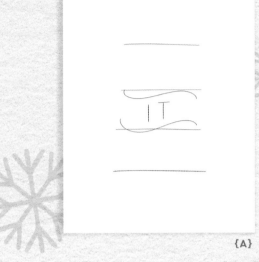

{A}

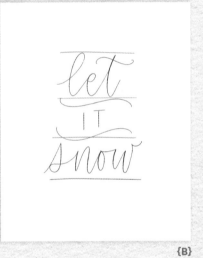

{B}

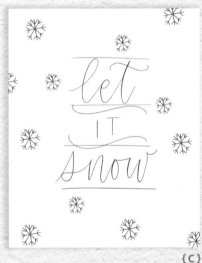

{C}

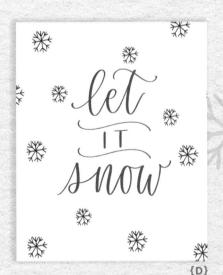

{D}

PRACTICE

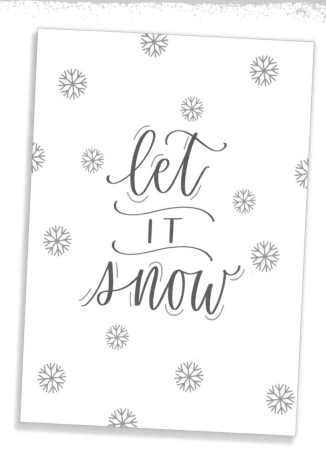

May Your Holiday Be Sweet

By Veronica Ruiz

Add a sweet touch of handmade goodness to your presents with this card. This candy-cane themed design would pair well with a box of homemade Christmas treats or any item you want to gift with love. Break out your permanent markers and create a cute card in no time!

WHAT YOU'LL NEED:

- White card stock
- Pencil and eraser
- Black fine line drawing pen
- Red and green permanent markers
- White gel pen

WHAT YOU'LL DO:

1. With your pencil, sketch out your illustrations and words on the card stock. Frame the top and bottom of your piece with candy canes and candy-cane letters, respectively, to keep the piece balanced. Use block letters for the word *sweet* to make it easier to draw the candy-cane stripes, and draw the rest of the words in script to add variety to the design {A}.

2. Thicken the downstrokes of your block and script letters. With your pencil, add a line parallel to every downstroke in your design. The script looks best when the downstrokes are thin, and the block letters look better with thicker downstrokes. Add diagonal candy-cane stripes to the block letters, drawing at least three stripes for each letter so the resemblance to a candy cane is easy to see {B}.

3. Trace your pencil lines with the black fine line drawing pen and erase any stray pencil lines {C}. Fill in the downstrokes only for your script letters.

4. Add color with your permanent markers and details with your white gel pen. Use a red marker to color in your candy-cane stripes and green to color in your leaves. With your white gel pen, add highlights to your candy-cane illustrations and letters to give them a three-dimensional look. Just draw a white line to the left side of every letter and illustration.

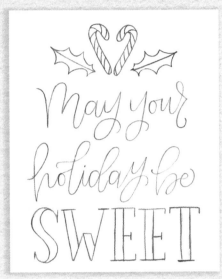

{A}

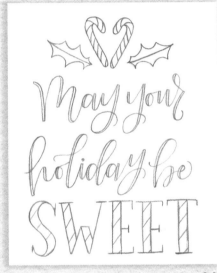

{B}

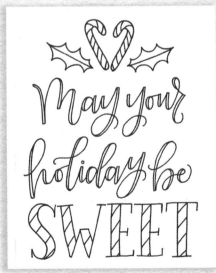

{C}

PRACTICE

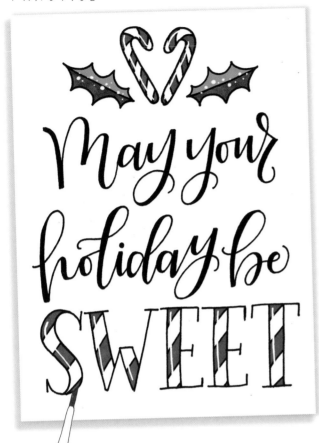

May your holiday be SWEET

Merry Christmas

By Hazel Nguyen

This design showcases colored lettering on white card stock with leaves and berries for embellishment. Add some flourishes to your letters for extra sass, and you've got yourself a design for a Christmas card that you can give to your loved ones this year and for many years to come!

Tip After you make your sketch, go over it with an eraser, removing as much of your pencil marks until they are very faint and barely visible. This will ensure the pencil lines are not visible when you create your final design.

WHAT YOU'LL NEED:

- Card stock
- Pencil and eraser
- Ruler
- Red and green fine-tip brush pens

WHAT YOU'LL DO:

1. Use a pencil and ruler to draw two faint lines in the center of the card stock. Using these penciled guidelines, letter *Merry Christmas* in script in the center of the card {A}. Remember to use thin upstrokes and thick downstrokes. Add the flourishes in the letters *M* and *s*. Make sure you add the flourishes after sketching your letters. Saving your flourishes for last helps you better visualize where you can place and add each one.

2. With a pencil, draw a total of four branches, two on the top left corners and two on the bottom right corners of the card stock, making sure you leave enough room to draw your leaves {B}. Add three leaves to each branch in an alternating pattern. Then add two berries at the bottom of each branch. You can add more berries along the branch, but check that it doesn't look too busy—less is more.

3. With your red brush pen, trace Merry Christmas. With your green brush pen, trace the leaves. Use the red brush pen to draw the berries. Let the ink dry before erasing any pencil lines.

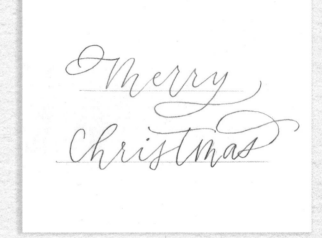

{A}

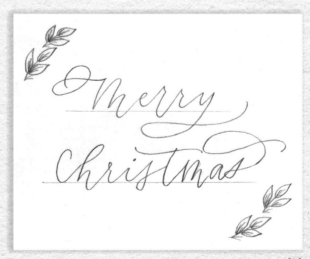

{B}

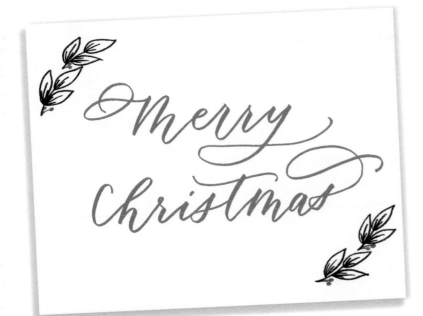

Wishing You a Very Merry Christmas

By Winterbird

This piece features many exaggerated and decorative flourishes. When working on a lettering piece with a lot of decorative elements, it is important to make sure that the main message is still legible. Try keeping the strokes in your letters dark and thick, while making your flourishes lighter and thinner.

WHAT YOU'LL NEED:

- Pencil and eraser
- Ruler
- Sketching paper
- Light box or tracing paper
- Card stock
- Colored pencils

Tip If you don't have a light box, you can use a window or tracing paper (see Using Tracing Paper, page 8).

WHAT YOU'LL DO:

1. Using a pencil and a ruler, draw three rows of guidelines for your letters in the center of a piece of sketching paper {A}. Each row should have two parallel horizontal lines. Leave some space between each row of guidelines to make room for flourishes.

2. With pencil, sketch out your letters inside your guidelines {B}. Focus on the position of the letters, and keep them evenly spaced and centered on the guidelines. You can erase and sketch them again and again until you are satisfied.

3. Place a new piece of sketching paper on top of the first one. Set both papers on a light box so you can see through the top paper easily. On this top piece of paper, we will begin flourishing the letters. Add flourishes to letters that stand high (like the letter *h*) or fall low (like the letter *y*) {C}. Let your flourishes run free, and allow some of them to interact with other letters (like the *h* and *t* in *Christmas*). Because you are sketching this on a separate piece of paper, it's easy to sketch again and again until you're happy with the "groundwork" of your flourishes.

4. On another new piece of paper, sketch your letters and flourishes based on your last sketch. This time, refine your flourishes and let them extend to the edge of the paper or make them end on the page. Trace over the ends of the flourishes that terminate on the page, to give them a rounded, flared shape {D}.

5. Add some stand-alone flourishes to fill in the most open areas. Let them curve and swirl around other flourishes. In the remaining open spaces, add cute little hearts to finish your sketch.

6. Place a sheet of card stock over your final sketch on the light box. Trace your sketch with your colored pencils to create the final piece. Remember to keep your letters bold and your flourishes light.

Tip Improve your flourishes by daring to "let go"—create the biggest flourishes with your whole arm in one big movement. As you're drawing a flourish, concentrate on where you want it to end up, rather than focusing on the tip of your pencil.

{A}

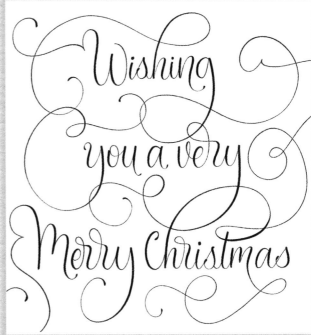

{B}

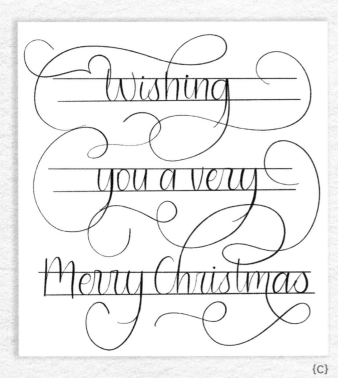

{C}

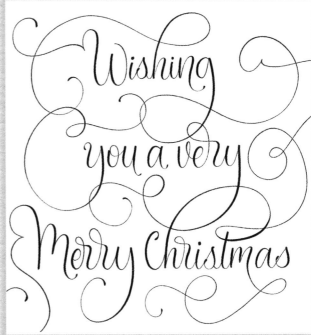

{D}

PRACTICE

Holiday Hand Lettering

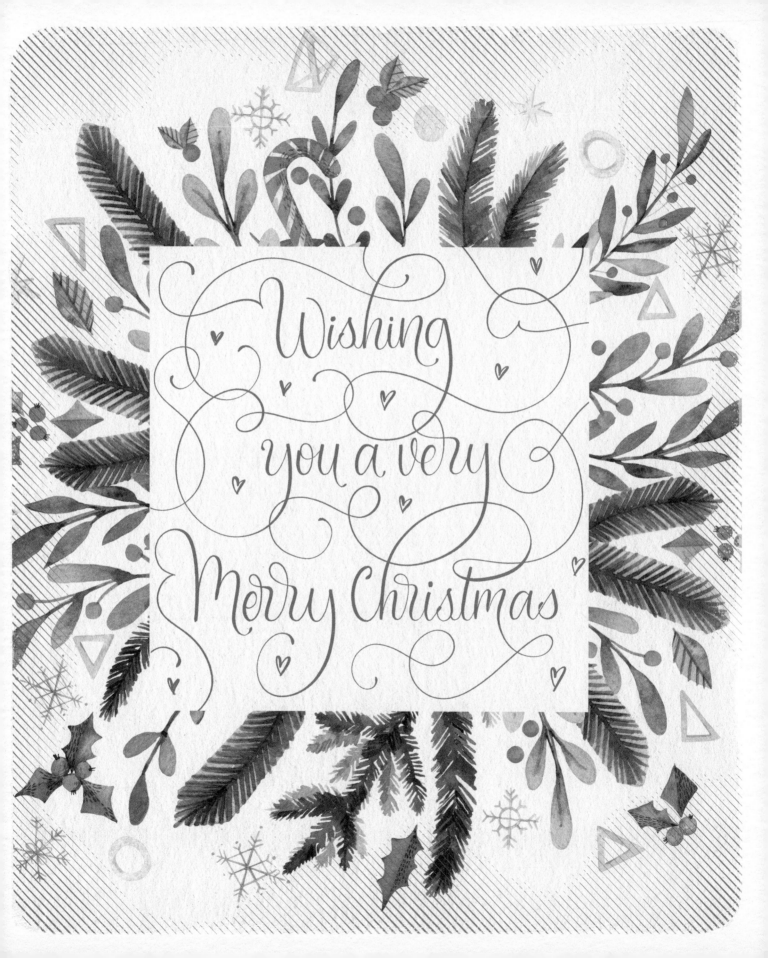

Let It Snow...Elsewhere

By Winterbird

Here's a design for everyone who prefers swimwear and iced tea instead of mittens and hot chocolate. This fun design uses watercolors to bring energy to the piece, but if you don't have watercolors, you can use your favorite markers or colored pencils.

WHAT YOU'LL NEED:

- Watercolor paper, any weight
- Pencil and eraser
- Ruler
- Watercolor paints
- Paintbrush or water brush
- Black fine line pens, 0.2 mm and 0.45 mm
- Scissors or paper cutter

Tip You can easily change the palm tree illustrations in my example and draw anything you like. Here are some suggestions: sunglasses, a bikini, lemonade, parasol, surfboard, and the beach.

WHAT YOU'LL DO:

1. Begin sketching on your watercolor paper. Using a pencil and a ruler, draw a rectangle to mark the edges of your piece; you will cut out your piece using these marks. Then draw two horizontal and centered guidelines for each word {A}. Note the guidelines are narrower for the word *it* because it will be lettered smaller than the others.

2. Sketch the words. To draw attention to *Let It Snow* at the top of the page, add extra weight and flourishes to the letters {B}. Make sure that you have enough space around them to add illustrations. Adjust the letters until you are happy with their placement.

3. Sketch out illustrations around the letters {C}. In this example, I added some palm trees, a sun, a couple of clouds, and a bright blue sky to convey the feeling of summer. Don't worry if some parts of your drawings overlap your letters, as long as your words are still easy to read.

4. Using watercolors and your paintbrush or water brush pen, add colors in the background of your piece {D}. Make sure your color extends a little bit beyond your cutting marks. Let the paint dry.

5. Add colors to the rest of your illustration {E}. Your piece doesn't need to be perfect, and if some colors mix together, that is perfectly all right. Let it fully dry.

6. Using your 0.45 mm pen, outline your illustrations and for your letters. Add smaller details using the 0.2 mm pen {F}.

7. Once the ink from the fine line pens is dry, erase all the pencil lines, with the exception of your cutting marks. Trim your paper along the cutting marks and then erase any last trace of pencil.

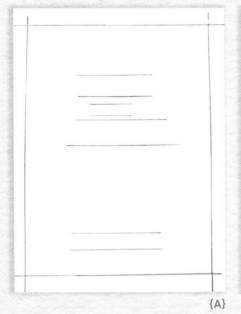

{A}

{B}

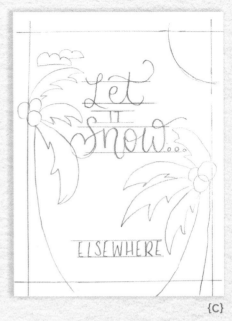

{C}

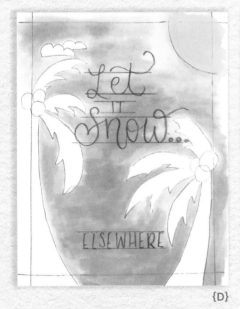

{D}

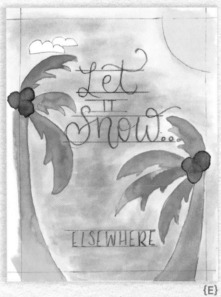

{E}

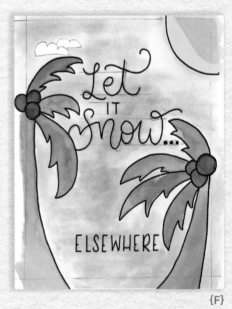

{F}

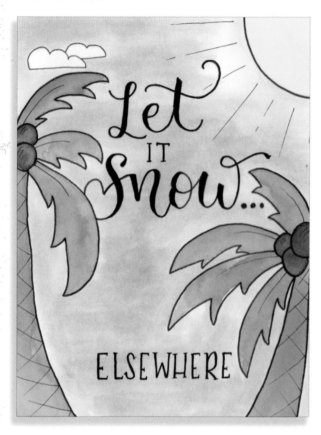

Good Tidings of Comfort and Joy

By Colleen Wilcox

What brings you comfort and joy? This design will inspire you to think about things that make you happy during the holidays. I borrowed these words from the traditional Christmas carol "God Rest Ye Merry Gentlemen." In this design, I use only colored markers. One of the beautiful things about hand lettering is that you can use any writing utensil you want. The sky's the limit!

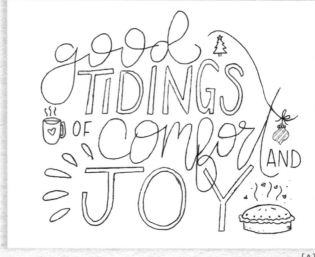

{A}

WHAT YOU'LL NEED:

- Card stock
- Pencil and eraser
- Red fine-tip marker
- Colored ultrafine-tip markers, including green

WHAT YOU'LL DO:

1. Begin by sketching the letters with a pencil. For this design, don't worry about sticking to straight lines. I incorporated three styles of letterforms in this piece: cursive, outlined, and filled. The cursive letters of *good* and *comfort* are more playful, while the outlined words *tidings* and *joy* are more serious. *Of* and *and* are less important and therefore smaller. Play with the shapes of the letters and use any curves to your advantage. Add doodles to fill the space {A}.

Tip Connecting letters is one way to add flow to your design. Here, I attached the cross of the *t* in *comfort* to the end of the *d* in *good*.

2. With the red fine-tip marker, start drawing the cursive words. For the outlined font, use a green ultrafine-tip marker {B}.

3. Use the red marker to thicken your cursive letterforms and draw over the downstrokes to add more width and weight. By thickening your downstrokes, you make the font look as if it was made with a brush instead of a marker. I also used the red marker to add the accents surrounding the left side of *joy* {C}.

4. Using any ultrafine-tip markers you have on hand, add color to your doodles {D}. Use the practice space on page 33 to brainstorm things that make you happy during the holiday season, and draw them around your text.

Tip This lettering style leaves some space to fill, so why not add happy drawings to bring you joy? Remember, make your design mean something to you! When lettering this design, I had coffee and pie in mind as things that bring me comfort and joy.

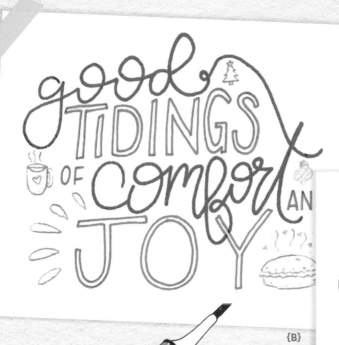

{B}

{C}

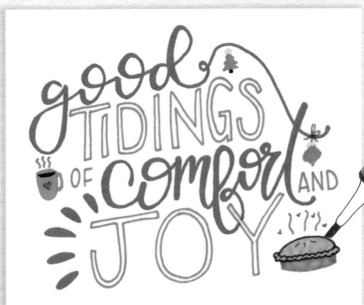

{D}

PRACTICE

PROJECTS ON PAPER 33

Stay Warm & Cozy

By Winterbird

This piece uses a knitting-inspired motif to create an eye-catching design for a card or framed wall art. I was inspired by traditional Norwegian knitting motifs as well as the mittens that my grandmother made for me. Graph paper can be helpful when you are sketching both the letters and the motif. If you'd like to save time, use the pattern on page 35 and go straight to step 4.

{A}

WHAT YOU'LL NEED:

- Pencil and eraser
- Ruler
- Sketching paper
- Light box or tracing paper
- Graph paper
- Colored fine liner pens or colored pencils
- Card stock or kraft paper

WHAT YOU'LL DO:

1. Using a pencil and a ruler, draw guidelines for your letters and illustrations on your sketching paper. Make four horizontal rows with a little space between each one and eight vertical columns {A}. You will use one row for each word, the two columns at each side for the illustrations, the next two columns for spacing, and the four innermost columns for the letters.

2. Following the guidelines, create a rough sketch of the letters and knitting motifs {B}. Keep the design of the letters and motif simple.

3. Place your sketch on a light box and a piece of graph paper on top to create the sketch of the knitted motif. Simulate knitted fabric by drawing small *v*'s with your pencil within the illustrations on the left and right side. Continue making tiny *v*'s for your letters {C}.

4. Place your card stock or kraft paper over your final sketch. Use colored fine liner pens or colored pencils to trace the sketch and create your final design. You can create a gradient by using darker colors at the top of the letters and illustrations and gradually easing into brighter shades as you move toward the bottom.

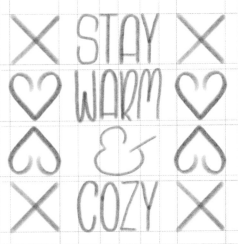

{B}

{C}

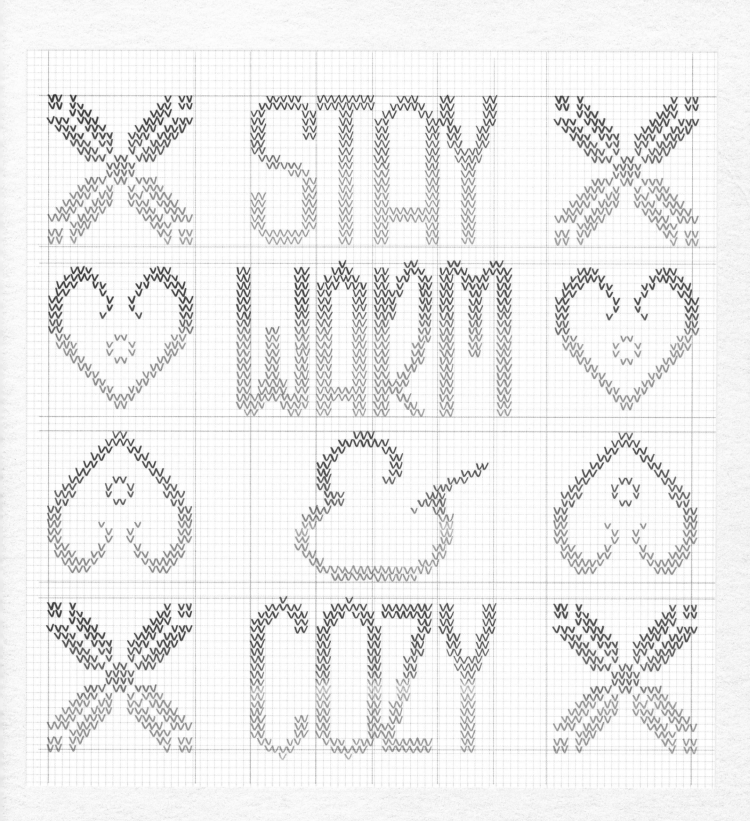

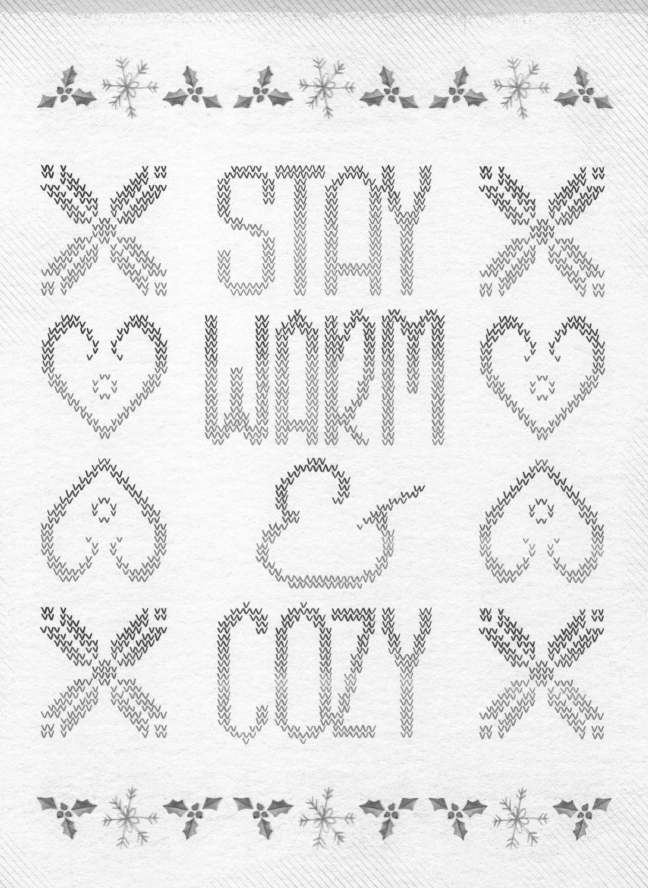

Feliz Navidad

By Veronica Ruiz

It's time to have some fun with colored pencils and Christmas lights! It's super easy and fun to customize the color of the light bulbs and the way they trail across your page. Plus, it's a great change of pace to letter *Feliz Navidad* after drawing *Merry Christmas* so much during the holiday season!

{A}

WHAT YOU'LL NEED:

- Pencil and eraser
- White card stock
- Colored pencils, including gold
- White gel pen

Tip Before tracing your pencil marks with the colored pencils, use an eraser to lighten the pencil lines without completely erasing them. This will help prevent the pencil lines from showing through the colored pencil.

WHAT YOU'LL DO:

1. On your card stock, sketch your lights and letters very lightly with your pencil {A}. I used the Swirly Skates alphabet provided on page 125 to match all the swirls of the lights. Feel free to have fun with the loops of the string of lights! Choose any colors you'd like for the light bulbs. Traditional colors include red, orange, blue, and purple.

2. Lightly trace your pencil sketch with the colored pencils. Fill in the light bulbs as well {B}.

3. Add a second, darker layer of color to your lights to give some dimension and simulate a shadow on the bulbs {C}. This darker layer will only cover one side of the light bulb, from the base of the bulb curving up to the tip.

4. Darken the lines for your letters and thicken the downstrokes. With your colored pencil, add lines parallel to every downstroke of your letters. Leave very little space between the parallel lines. Add sparkles by drawing dots of various sizes using a gold-colored pencil. For the white highlights on the bulbs, use your white gel pen to add a small line on the opposite side of your shadow.

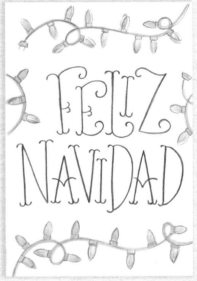

{B}

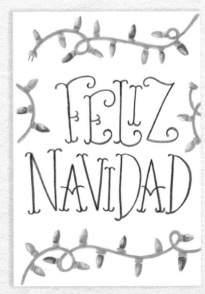

{C}

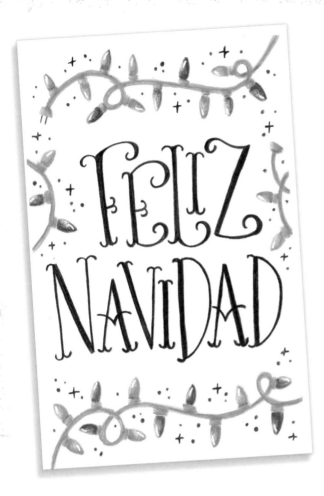

All Is Calm, All Is Bright

By Colleen Wilcox

Hand-lettered designs in shapes are a favorite of mine. They offer a visually interesting and clever way to get your message across. For this design, I chose a Christmas-light shape. It's a simple one with a lot of space for lettering and something that people can recognize from a distance. This phrase is borrowed from one of my favorite Christmas songs, "Silent Night."

{A}

WHAT YOU'LL NEED:

- Card stock
- Pencil and eraser
- Red, green, and yellow fine-tip colored markers
- Red, green, and yellow ultrafine-tip markers

WHAT YOU'LL DO:

1. Sketch the Christmas-light shape out in pencil on your card stock {A}. Draw lightly—these lines won't stay for long!

2. Sketch the words using large, uppercase letters inside the shape. Fill up as much space as you can {B}. You want the shape to be visible after you erase its outlines later, so try to align the edges of your letters with the sides of the shape. Sometimes you'll need to erase and redraw to make them fit. That's fine! Hand lettering is a process, and you can't always do it perfectly the first time.

3. With the colored markers, fill in the letters. I like to use a variety of markers with different tips so that it's easier to create small details.

Alternate the colors you use to differentiate each word {C}. If there is extra space inside the shape, feel free to add some festive doodles, like the stars shown here. Remember, you want to fill any large empty spaces so that the Christmas-light shape is easily discernible.

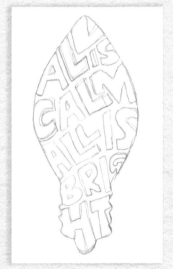

{B}

4. Erase all of your pencil lines, starting with the outline of the Christmas-light shape. You'll begin to see how the letters and negative space work together to form the shape of the Christmas light.

Tip Hand-letter this design on small squares of card stock to create unique gift tags for family and friends.

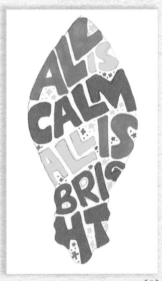

{C}

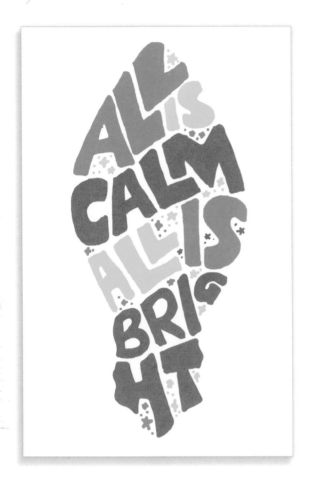

Star of Wonder, Star of Night

By Colleen Wilcox

Some hand-lettered shape designs are tougher to draw than others. A star falls into this category, because there isn't much space at its points. However, I think the challenge makes you a better lettering artist! This phrase is derived from a well-known holiday song that I enjoy singing, "We Three Kings." For this design, you want to use a sturdy card stock because you will be using a lot of ink.

WHAT YOU'LL NEED:

- Sturdy card stock, 100 lb (260 gsm)
- Pencil and eraser
- Blue ultrafine-tip marker
- Colored markers
- White paint pen or silver metallic marker

WHAT YOU'LL DO:

1. Start by sketching out a star in pencil on your card stock **{A}**. If desired, you can print out a star graphic and trace the shape, or draw it freehand.

2. With your pencil, draw the letters within the star **{B}**. I like to create cartoon-like letters that are easy to read and easy to manipulate so that they fit inside the star. The letters do not need to be all the same size. Because you want the star to be identifiable, align the edges of your letters with the pencil outline as best you can. You might have to elongate or shrink some of the letters, especially in the star's points. If it's hard to fit all the letters, try to stack them on top of each other, as I've done in this example with the *o* and *f* in *of*.

{A}

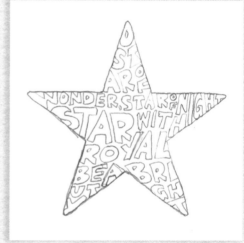

{B}

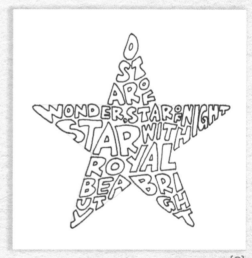

{C}

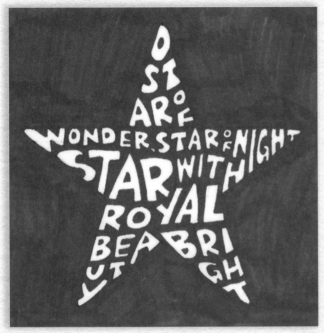

{D}

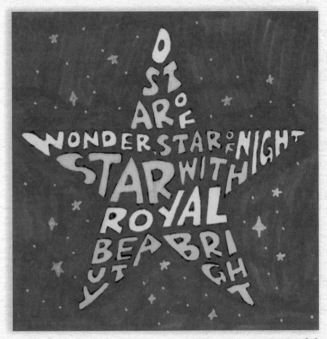

{E}

Tip To place the letters in a way that is as easy to read as possible, start sketching the words at the top, moving from left to right. Align the letterforms in a way that allows them to fill the space while still remaining legible. Create different-sized letters, making less important words (such as *of*) smaller, while enlarging those you want to stand out, such as *star*.

3. With the blue ultrafine-tip marker, outline the letters {C}.

4. Using a thicker blue marker, fill in the space around the letters {D}. Your piece will look more cohesive if you have a larger marker in the same color as your ultrafine-tip marker.

5. Color in the letters. You'll want to use markers with a thicker tip. Try filling in the letters using different shades of the same color, which will enhance your design and make the words within your shape easier to read. I chose to make the star yellow. Using a white paint pen or silver metallic marker, add some star doodles to your galaxy {E}!

O STAR OF WONDER, STAR OF NIGHT STAR WITH ROYAL BEAUTY BRIGHT

Jingle, Jingle, Jingle

By Marie Hermansson

When you're lettering a phrase with several words, you can combine different styles of lettering to make your drawing stand out. This design uses sans serif and ornate-style lettering with V-shaped ends to create a distinctive piece.

WHAT YOU'LL NEED:

- Pencil and eraser
- Drawing paper
- Ruler
- Black fine-tip pen, any width between 0.5 and 0.8 mm
- Fine-tip colored paint pens, 0.9 mm

WHAT YOU'LL DO:

1. With your pencil, lightly sketch out your phrase and the decorative swirls around it on drawing paper {A}. Use your ruler to determine the best angle for each word; drawing your words at an angle can add movement to your piece. In this illustration, the angled words help communicate the real-life movements of jingling bells. For the first and last words, draw inverted V-shaped lines at the ends of each letter.

2. Add inline details to your letters and thicken the curled ends of your swirls {B}. I used three different inline details to add variation to the three repeating words: simple lines for the first word, a feathered shape for the second word, and dots for the third word. For the third word, I also drew thin lines around the bottom and right sides of the letters to give each one more dimension.

3. Using a fine-tip pen, ink your drawing. Erase pencil lines after the ink dries {C}. If you want to avoid visible black lines in your final piece, you can skip to step 4, gradually erasing the pencil lines as you color the piece.

4. Add color using paint pens. Pink, red, and gold make a festive color palette. Use both pink and red for the letters, alternating between the two colors for the second and third words, and outline the inline details and swirls in gold to add more visual interest {D}.

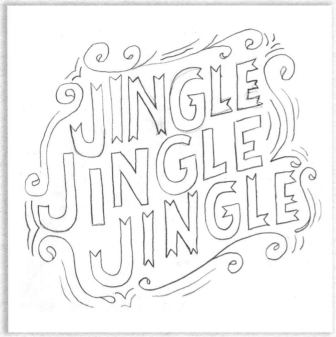

{A}

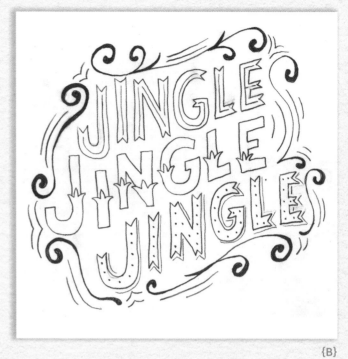

{B}

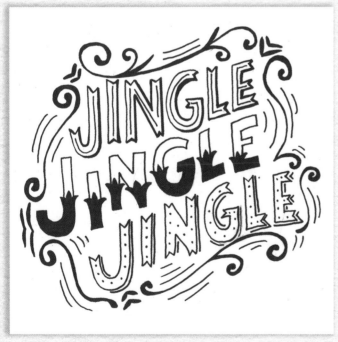

{C}

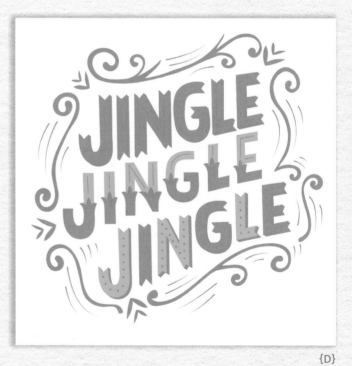

{D}

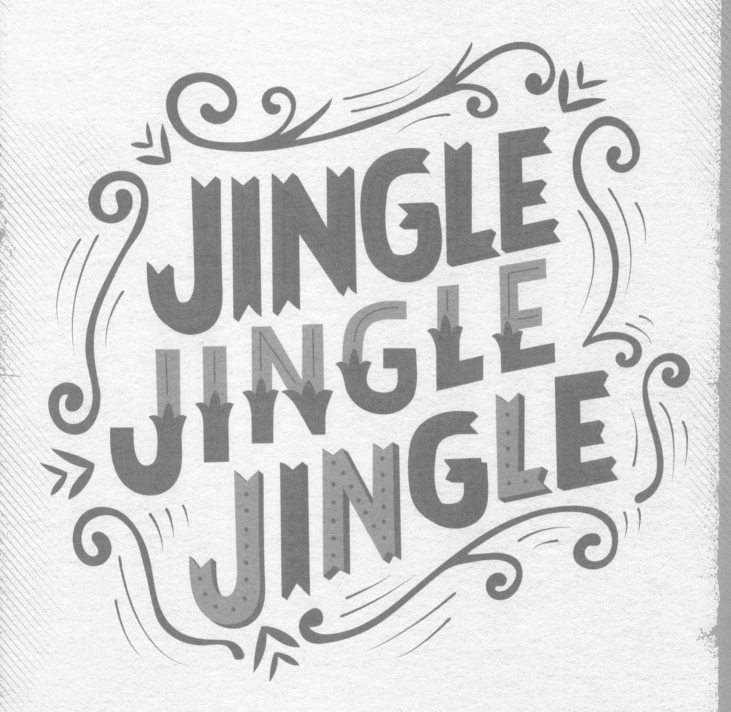

Merry & Bright

By Hazel Nguyen

In this cheerful holiday design, you can find some pine needles, red berries, boughs, and holly arranged in a delicate wreath. This design also uses watercolor. What I love about watercolor is that it is a very forgiving medium, and if you are new to it, here is your chance to practice.

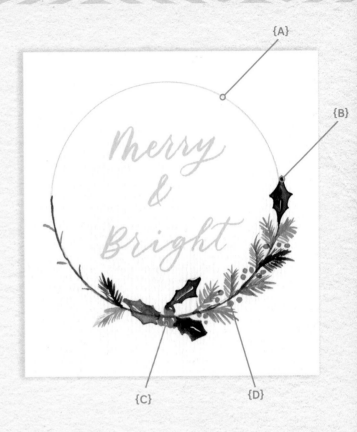

WHAT YOU'LL NEED:

- Pencil and eraser
- Drawing compass
- Watercolor paper, 140 lb (300 gsm)
- Brown, green and red watercolor paints
- Paper towel
- Round water brush, size 1 or smaller, or paintbrush
- Black fine-tip brush pen
- Gold gel pen or gold watercolor paint (optional)

WHAT YOU'LL DO:

1. Use a pencil and compass to lightly trace a circle with a 3½-inch (9 cm) diameter in the center of the card. Write *Merry & Bright* in script in the middle of the circle {A}.

2. Dip your water brush into brown watercolor paint and trace the bottom half of the circle to create the branch for the wreath. Leave the upper half of the circle blank. Let it dry.

3. Rinse your water brush, dab on a paper towel to remove excess water, and dip it into green watercolor paint. Starting at the right end of the branch, make your first holly leaf, outlining the shape of a leaf first and coloring it in with your watercolor {B}. Leave a white space in the middle of your leaf to create a highlight in the center of the leaf vein. Add clusters of pine needles in green, stopping just before you reach the center of the wreath.

> **Tip** To add contrast and make your pine needles look feathery, you can mix or layer dark and light greens for the pine needles. Alternatively, use a lighter shade of green throughout the wreath and, once dry, layer a darker shade of green on the lighter green.

4. Rinse your water brush, dab on a paper towel, and dip it into red watercolor paint. Make three small circles for the berries at the center of the wreath {C}. Again, leave a white space at the top corner of each berry to create a highlight. Rinse your water brush again, dab on a paper towel, switch to green paint, and then add three holly leaves around the cluster of berries {D}.

5. Repeat step 4 to add pine needle clusters along the other half of the branch. When you reach the end of the branch, create another holly leaf.

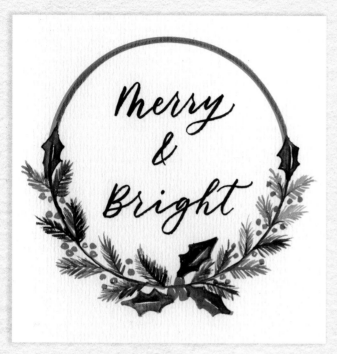

{E}

6. Rinse your brush again, dab on a paper towel, and pick up the red paint. Add berries to fill in the space between the pine leaves around the wreath. Let the piece dry.

7. If you want to add some shine, trace the top half of the circle with gold watercolor paint or a gold gel pen {E}. Before adding the gold ink, erase as much of your circle sketch as you can to prevent the pencil lines from showing through.

8. Once the wreath is dry, trace *Merry & Bright* with the black brush pen. Using an eraser, remove any excess pencil sketch lines, if any are visible.

PRACTICE

Fa La La La

By Veronica Ruiz

This piece is all about having fun creating different styles for the same letters. This phrase comes from "Deck the Halls," an iconic Christmas song, but the art can seem boring if you make all the *l*'s and *a*'s look the same. This piece encourages you to find new ways to write each letter to create a truly unique piece—all of this while playing with watercolor and peppering in some illustrations too!

WHAT YOU'LL NEED:

- Ruler
- Pencil and eraser
- Watercolor paper, 140 lb (300 gsm)
- Watercolor paints
- Paintbrushes
- Gold gel pen
- Broad-tip white gel pen

WHAT YOU'LL DO:

1. Using your ruler and pencil, create a grid with four rows and three columns on the watercolor paper. Fill each square in the grid with a letter or illustration as shown {A}. The alignment of the letters alternates between the left and right of each row so the composition as a whole looks more balanced. For the illustrations, pick items that remind you of Christmas, or, if you want to make it a music-themed piece, add music notes in the squares without the letters.

2. Fill in the background of your squares with watercolor paint in alternating colors {B}. Be careful to avoid coloring inside the lines of the letters or illustrations; because water-color is translucent, it may be difficult to cover up sections that have been filled with other colors. Let the piece dry. If you want your watercolor to dry more quickly, use a hair dryer on the cold setting to help speed up the process.

 Tip If you do get a little bit of color in the wrong spot, immediately clean your brush, use it to add clean water to that spot, and dab with a paper towel. It may not disappear completely, but it will be significantly lighter.

3. Paint in the letters and illustrations {C}. For now, leave out any part that you want to remain white or fill in with gold pen. Let the piece dry.

4. Use your gold gel pen to add gold accents to your illustrations and letters {D}. In this piece, only the bell and tops of the ornaments have gold added, but feel free to add more in your letters as well. With the white gel pen, trace all of your pencil lines. A broad-tip white gel pen will cover the pencil lines more effectively than a standard fine-tip white gel pen. You can add a border in between the boxes using small dots. Don't worry about evenly spacing the dots.

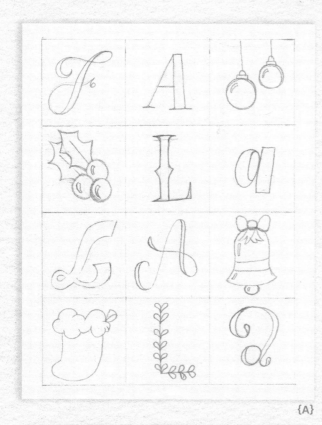

{A}

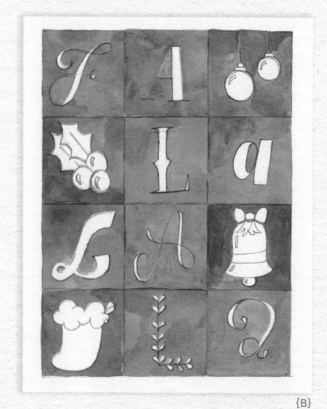

{B}

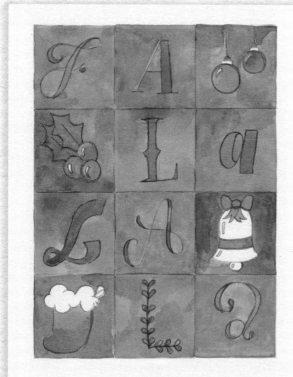

{C}

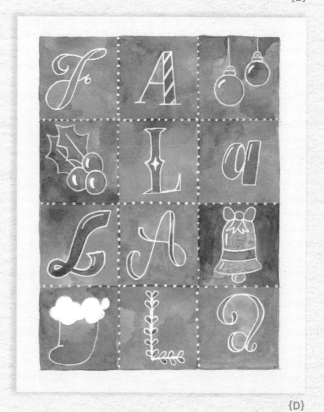

{D}

Holiday Hand Lettering

Ho, Ho, Ho

By Marie Hermansson

Incorporating illustration into your lettering is a fun way to add extra visual interest. Here the words are arranged in the shape of Santa's beard. You'll start by sketching your illustration, then fit your lettering within the spaces of that drawing.

WHAT YOU'LL NEED:

- Drawing paper
- Pencil and eraser
- Black fine-tip pen, any width between 0.5 and 0.8 mm
- Red and blue fine-tip colored paint pens, 0.7 mm

WHAT YOU'LL DO:

1. Lightly sketch out your drawing of Santa and the letters on drawing paper in pencil {A}. Make sure to leave enough space to fit the letters inside Santa's beard. You'll notice that your letters decrease in size as you move toward the tip of the beard and follow the curve of the beard, which adds to the whimsical look of the piece.

2. Add more details to your drawing and lettering {B}. I drew small strokes on the fur trim of Santa's hat and the hair of his beard and added inline details to the letters. Inline details, such as the diamonds and the V-shaped lines in the middle of each letter, give your lettering a simple decorative look.

3. Using the black fine-tip pen, ink your drawing. Erase the pencil lines after the ink dries {C}. If you want to avoid visible black lines in your final piece, only ink the features on Santa's face, the trim and pom-pom of the hat, and the right-hand edges of the letters.

4. Add color using the paint pens {D}. I used a bright and modern color palette featuring aqua blue and a soft red.

> *Tip* You can paint this design on a piece of wood to use for holiday home décor. Make sure to properly clean the wood surface before painting. Use acrylic paint and brushes for rough textured wood, such as barn wood. Paint pens will work well on wood with a smoother surface, such as what you find at a craft supply store.

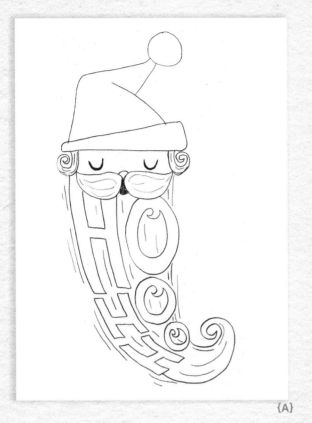

{A}

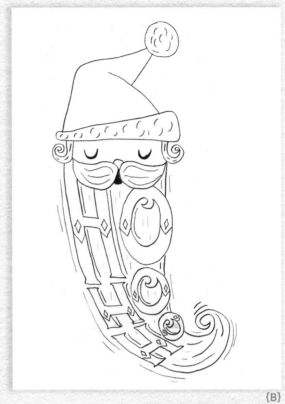

{B}

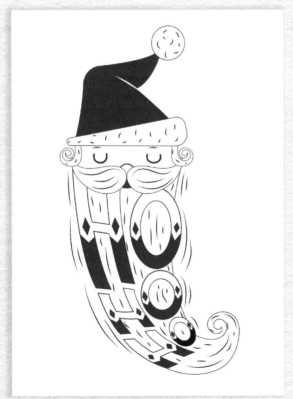

{C}

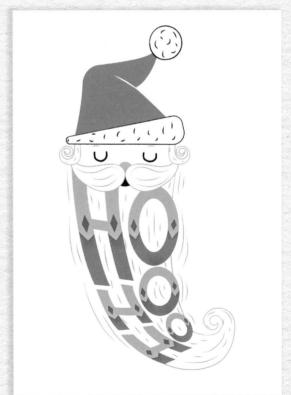

{D}

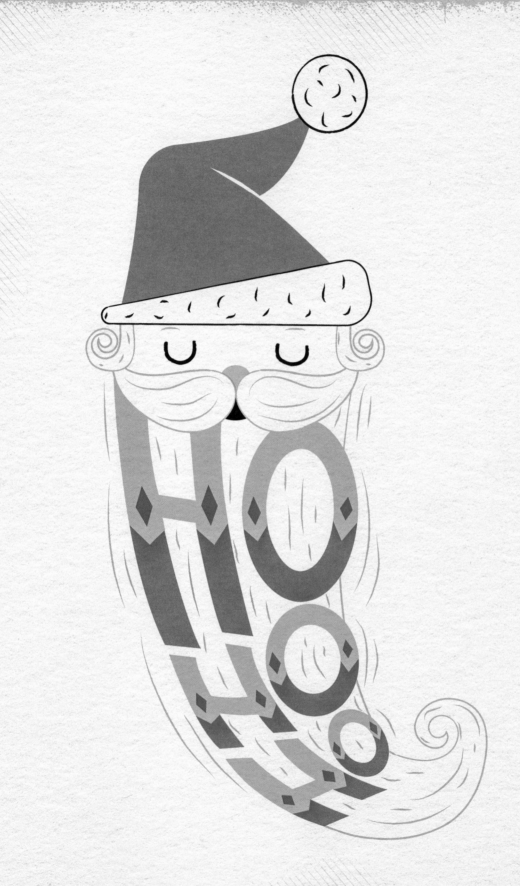

I Will Honor Christmas

By Colleen Wilcox

This poignant holiday quote comes from Ebenezer Scrooge, the protagonist of one of my favorite Christmas stories, *A Christmas Carol* by Charles Dickens. For this cute design, you'll hand-letter the quote within a Christmas ornament shape and use different font styles, such as brush lettering and outlined lettering. Because you draw the outlines of the letters first, this project is like creating your own page for a coloring book!

{A}

WHAT YOU'LL NEED:

- Pencil and eraser
- Card stock
- Black fine line pen, 0.5 mm
- Black fine brush pen
- Black fine-tip ink pen, 0.3 mm
- Colored markers

WHAT YOU'LL DO:

1. Sketch the ornament shape out in pencil on the card stock {A}. There are many different shapes to choose from, so pick one you like, or copy the one I used here. Add some extra shapes, like a ribbon and a bow.

2. Sketch the letters within the shape and use different font styles to fill the space {B}. Try to use most of the space. I like to vary the lettering styles to add contrast and weight to certain words, such as **Christmas** and **keep**.

Think about the wide range of ornament designs that you've seen, and allow that to inspire your letterforms. Add some doodles around the ornament. I always enjoy drawing snowflakes in my winter designs!

3. With the 0.5 mm black fineliner, outline the ornament shape and the letters. This pen will create a medium-thick line. Fill in some of the letters, if you'd like to add some variety to the styles and make some words stand out.

4. With a brush pen, fill in your cursive letters. A brush pen with a fine tip is helpful here because you'll work in a small space and want thin lines.

5. Add details with the 0.3 mm pen. Fill in the rest of the design with shading lines, snow, or any other extra details you want. Erase all your pencil lines to reveal your final design {C}.

6. Color in your design with markers of your choice. Fill in the letters and doodles to make your design shine!

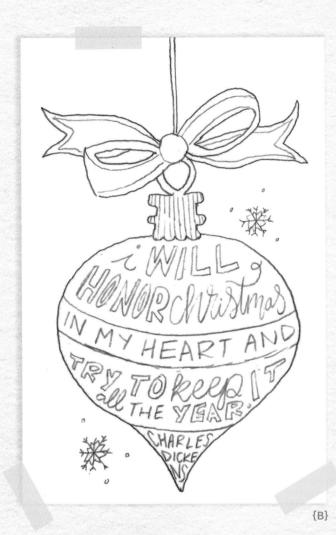

{B}

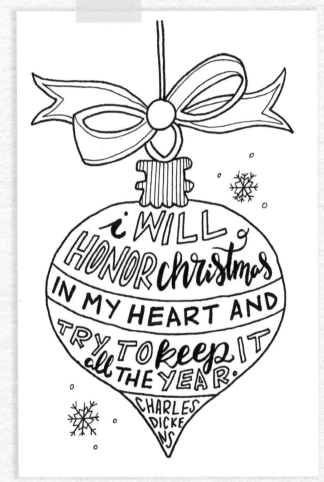

{C}

Tip Leave the design in black and white and gift it with a set of markers for a creative holiday present!

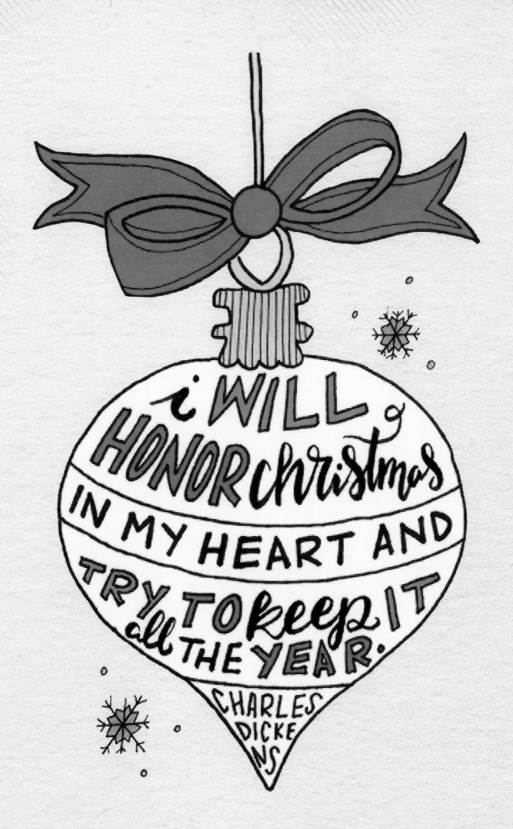

Wishing You
Joy for the Holidays

By Marie Hermansson

Send holiday greetings using this fun hand-lettering project. Here, you'll learn how a combination of various lettering styles can create a piece with lots of charm.

WHAT YOU'LL NEED:

- Drawing paper
- Pencil and eraser
- Ruler
- Drawing compass
- Fine-tip colored paint pens, 0.9 mm, including white

WHAT YOU'LL DO:

1. Lightly sketch the phrase in pencil. For *wishing*, use your ruler to draw two parallel angled guidelines for the second half of the word. Line up the bottoms and tops of the letters *h*, *i*, *n*, and *g* with the angled guidelines. Sketch *joy* in script and *for the* in thin capital letters in separate lines underneath, and add *you* in the space between the angled part of *wishing* and the word *joy*. Beneath these words, use a compass to draw the bottom curve of a circle and a straight line underneath the curve.

Draw the letters for the word *holidays* between the curved and straight lines, lining up the tops and bottoms of the letters with the guidelines {A}. Drawing the letters using different angles and sizes creates a more dynamic composition.

Tip When lettering a quotation or longer greeting, it can be helpful to sketch a few small designs on the practice space or separate pieces of scrap paper to lay out the piece before drawing it at a larger size on the final paper.

2. Add details to each word {B}. I drew different serifs for each word, except the words *for* and *the*. For *wishing*, I added

diamonds and V-shaped lines inside each letter. For *you*, I drew filigree, a swirly decorative element, and berries to highlight the holiday theme. For *wishing* and *holidays*, I used dots and lines to draw inlines.

3. Add color using paint pens. While red and green are two of the most traditional holiday colors, I freshened up that palette by using blue-green and a red-orange instead. Use a white paint pen to highlight the inline details for each word.

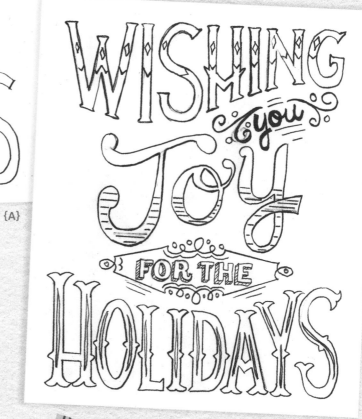

{A}

{B}

WISHING you JOY FOR THE HOLIDAYS

Christmas Is a State of Mind

By Colleen Wilcox

This wonderful quote is drawn from a Christmas-time message that US president Calvin Coolidge delivered on December 25, 1927. It reminds us that the holidays are about more than just material things. It's a great message to hang on the wall to inspire you during this season or to use for Christmas cards.

{A}

WHAT YOU'LL NEED:

- Pencil and eraser
- Card stock
- Ruler
- Black fine line 05 pen, 0.5 mm
- Black fine-tip marker, 1.0 mm
- Black fine-tip pen, 0.25 mm
- Colored markers

WHAT YOU'LL DO:

1. With a pencil and ruler, draw the guidelines you will use to block your design on card stock. In addition to creating straight horizontal lines, play around with diagonal ones and vary the distance between the lines to add some visual interest {A}.

2. Sketch out your lettered design {B}. Start with drawing the basic letterforms. Think about what words are more important than others. In this design, I want the words *Christmas* and *mind* to stand out. This design includes my favorite font styles: outlined letterforms and cursive letters. Next, move on to drawing the banner, then add all the detail drawings that you want. Here I incorporated doodles of lights, ornaments, snow, and more. Borrow from these eclectic doodles, or come up with your own!

3. Fill in the lines, using one type of black pen at a time {C}. First, I used a black 0.5 mm fine line ink pen, a good midweight pen that gives enough oomph to my lines while allowing me to still create detail. For small but more complex doodles, like the festive additions to *Christmas*, make sure to use the 0.25 mm fine-tip pen.

4. For the cursive words, use a heavier weight fine-tip marker, like a 1.0 mm, to fill in the letters. Once you're done, create a faux-calligraphy look by thickening the downstrokes, retracing and broadening those lines as needed {D}.

5. Outline the smaller details with the black fine-tip 0.25 mm pen {E}. Play with the space! I enjoy filling up the page with snowflakes and interesting accents like the ornament hanging from the word *state*.

6. Color in any outlined letters and doodles with the colored markers {F}. Filling in outlined letters is an easy way to make your design pop. Have fun with this step using any markers you have lying around!

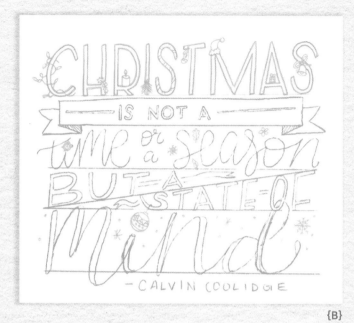

{B}

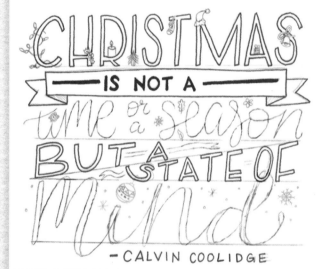

{C}

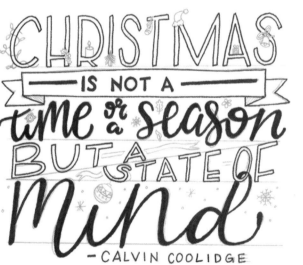

{D}

Christmas is not a time or a season but a state of mind.
— CALVIN COOLIDGE

{E}

PRACTICE

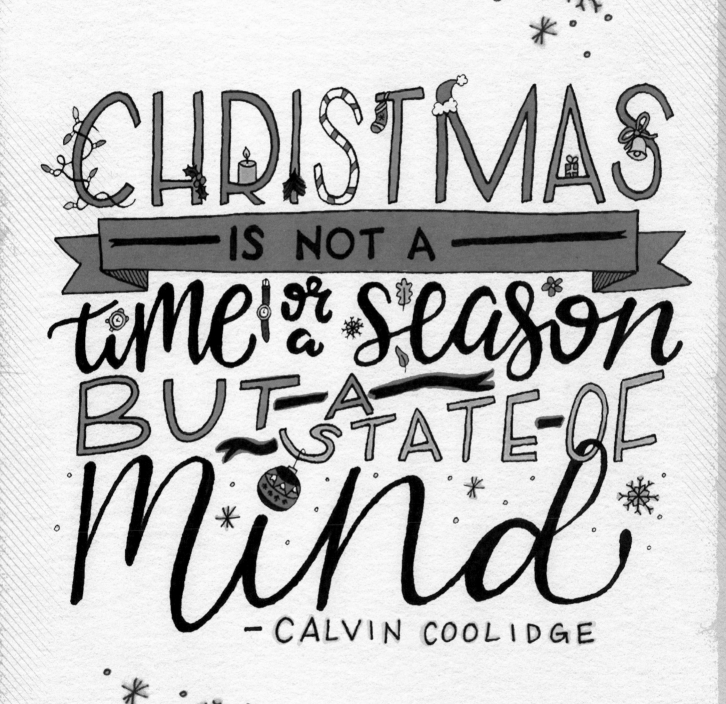

May the New Year Bring You Wassail

By Colleen Wilcox

In this hand-lettering design, you will be creating a list of things you hope the New Year will bring! It can be a positivity exercise or the basis for a New Year's card to send to loved ones this holiday season. The list that I lettered here plays on the lyrics from the holiday song, "Here We Come A-Wassailing," but you can add anything you want!

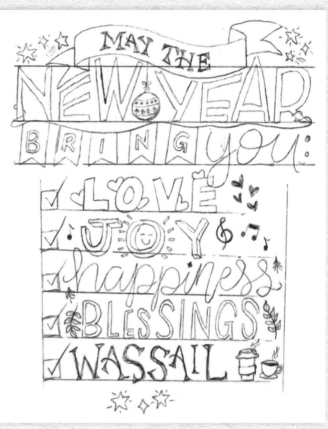

{A}

WHAT YOU'LL NEED:

- Pencil and eraser
- Card stock
- Black fine line pen, 0.5 mm
- Black fine-tip brush pen
- Black fine-tip ink pen, 0.25 mm
- Gray marker (or any color of your choice)

WHAT YOU'LL DO:

1. Using a pencil, sketch the lettered design on card stock. Begin with the banner at the top and the words *May the*, then add *New Year* to fill the space under the banner and *bring you* beneath that. Add the drawings around the letters, such as the ornaments, music notes, and stars shown here. Next create your list and checkboxes {A}. Don't feel like you always need to stick with one font for the listed items.

2. Start filling in your letters with the black pens. Vary your inking by using different pens and filling in some words while leaving others simply outlined {B}. Using many different styles, from filled and outlined letters to serif letters, adds whimsy to the design. I usually start with a midweight pen, such as the 0.5 mm pen, for the outlined letters, then move to the 0.25 mm pen to add finer details, such as the serifs on *Wassail*.

3. Ink the cursive letters with the brush pen {C}. I love mixing brush lettering and other fun fonts to create unique designs.

4. Start adding details and filling in any shaded areas. Here, I wanted *joy* to stand out, so I added shadows to the letters to give them depth. I created the festive doodles with the 0.25 mm fine-tip pen and filled in the banner and stars with the 0.5 mm fine line pen. For finer details like the leaves and steam, I suggest using the 0.25 mm pen.

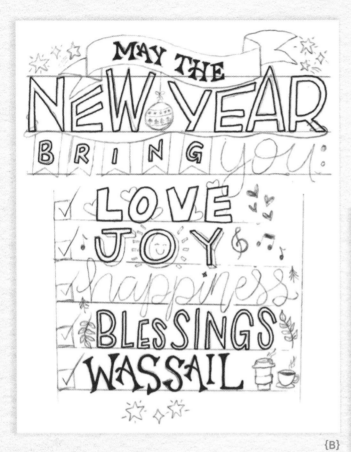

{B}

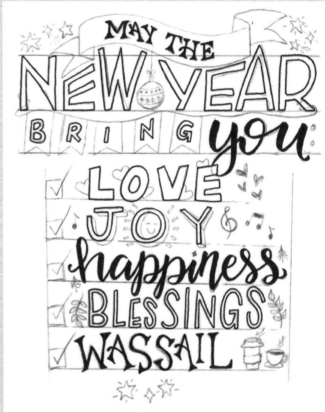

{C}

Tip To add dimension to your lettering, intertwine or connect your words (like the words *bring* and *New Year* here), or place some letters in front or behind other letters (as seen with the *y* in *you* and the *e* in *love*).

5. Erase all of your pencil lines. If you'd like to add more differentiation to any of the lettering, simply use a marker to add some color. Here, I stuck with a grayscale palette and used a gray marker to make New Year stand out.

PRACTICE

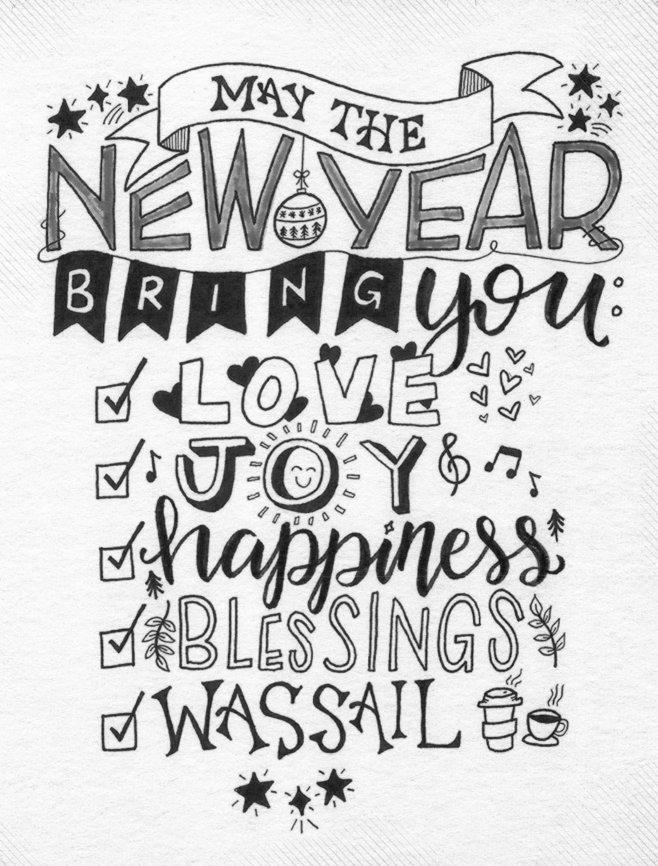

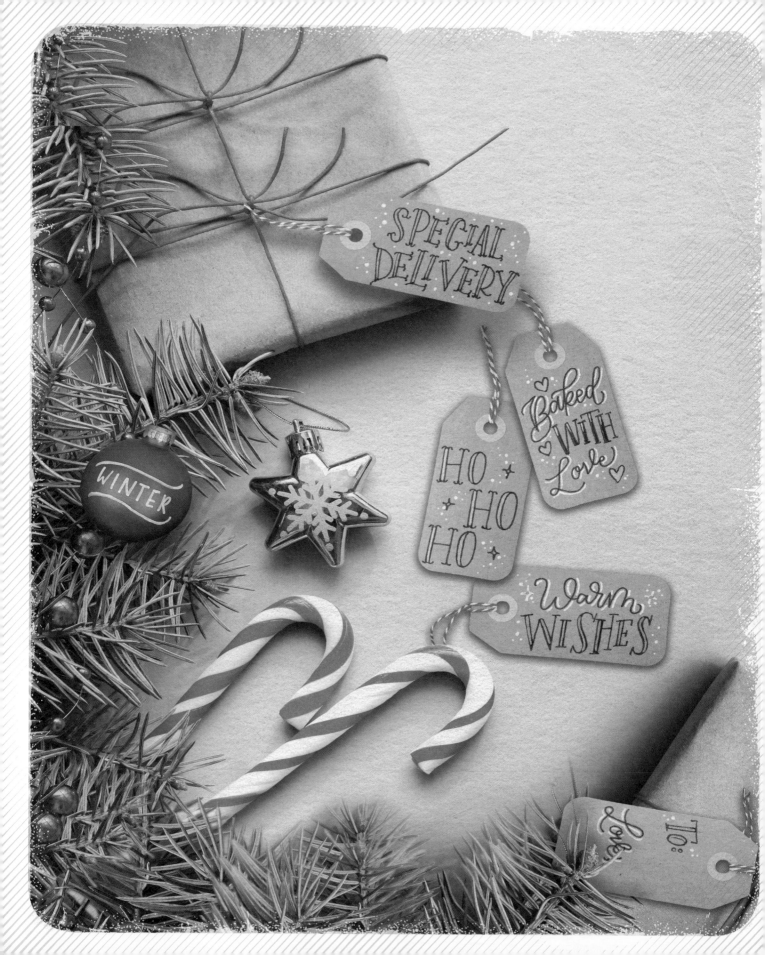

SPECIAL DELIVERY

Baked WITH Love

HO HO HO

WINTER

Warm WISHES

Love To:

PROJECTS OFF
THE PAGE

Peace, Love, Joy Banner

By Hazel Nguyen

Want to add some signage to a holiday party? How about a banner? This quick and easy design features watercolor lettering accented with ink splatters for a final touch. The watercolor paper that you're using for this project is perfect for a banner, especially because it's thicker than regular card stock.

WHAT YOU'LL NEED:

- Pencil and eraser
- Ruler
- Scissors
- Watercolor paper, 140 lb (300 gsm)

- Drawing compass
- Pencil and eraser
- Blue, red, and green watercolor paint
- Round water brush, size 2, or paintbrush

- $\frac{1}{8}$-inch (3 mm) hole punch
- Ribbon or twine

WHAT YOU'LL DO:

1. Using scissors, cut one sheet of watercolor paper to a 6 x 8–inch (15.2 x 20.3 cm) rectangle. With a pencil and ruler, first draw a faint vertical line in the middle of the paper and a horizontal line 2 inches (5.1 cm) from the bottom edge. Using these lines, draw a "v" shape at the bottom of your banner. Cut out this "v" shape. Erase your guidelines.

Tip To create a larger banner, divide the height of the banner by 4. This will determine how tall the "v" shape at the bottom of the banner should be. For example, if your banner is 12 inches (30.5 cm) tall, then the point of the uside down "v" should be 3 inches (7.6 cm) from the bottom.

2. Using a pencil, lightly sketch your design, placing each word on a separate line. I decided to use a mix of lettering styles to give the design some variety. I lettered the words **peace** and **joy** in all capitals and the word **love** in lowercase script {A}.

Tip After you create your sketch, make sure to go over your pencil lines with an eraser and make them as faint as possible without erasing them completely. Otherwise, the pencil sketch will show through the watercolor. Don't worry about some sketch lines showing. If they bother you, you can disguise them by adding more layers of paint as you finalize the design with watercolor.

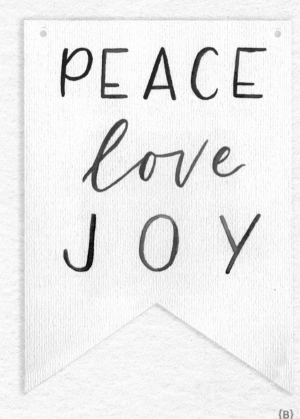

{A}

{B}

3. Dip your water brush or paintbrush in water to wet the bristles and pick up some blue paint. Trace the word **peace**, alternating between light and dark blue for each letter stroke to create a subtle gradient. Repeat for the remainig two words, but alternate between pink and red for **love** and dark and light greens for *joy* **{B}**. Make sure to rinse your brush when switching colors.

4. For the finishing touch, add some ink splatters. Dip your water brush in one of the three colors used in this piece. Without rinsing, dip it into another color. Using your nondominant åhand, flick the brush at the top of your project using your fingers or another brush or any lettering tool. Rinse your brush, and add more splatters using another color combination within the color scheme used for the piece. You can also choose to add ink splatters using one color at a time. Once the watercolor is dry, gently erase any unwanted pencil sketches. Erasing too hard may cause some watercolor to come off.

5. Use a hole punch to make a hole at each of the top two corners. Thread ribbon or twine through the holes and hang the banner where everyone can see and admire your work.

Monogrammed Stockings

By Shelly Kim

Delight your family and friends with these simple personalized stockings! Here are two different variations that I drew using stockings made from woven cloth. I prefer this material because I find that it is much easier to write on and the paint marker will not get caught on the fabric. Before you get started, don't forget to take time to brainstorm a design using the practice space.

WHAT YOU'LL NEED:

- 2 stockings
- Paint markers

WHAT YOU'LL DO:

1. For a single-letter design, draw any letter using the paint marker **{A}**. In this example, the letter **S** is written in a script font.

2. Draw a line parallel to the downstroke **{B}**. Next, fill in the space between the parallel lines to make the line appear thicker. Repeat for all the downstrokes in your letter.

3. If you like, feel free to thicken the upstrokes as well for a bold and opaque look.

4. Add some fun finishing touches by drawing a few outline strokes **{C}**. These strokes will make the overall piece pop.

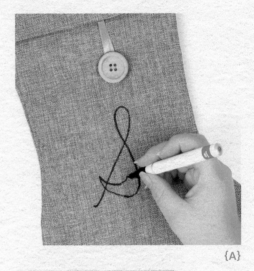

{A}

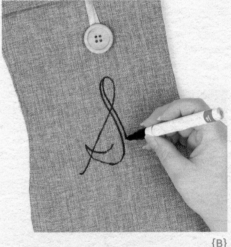

{B}

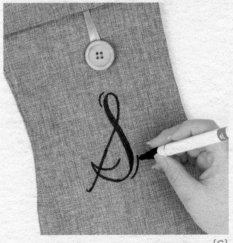

{C}

5. For the second stocking, you will hand-letter a pair of initials. Draw the letters that you've chosen for the initials {D}.

6. Repeat steps 3 and 4 to thicken the downstrokes and upstrokes {E}.

{D}

{E}

PRACTICE

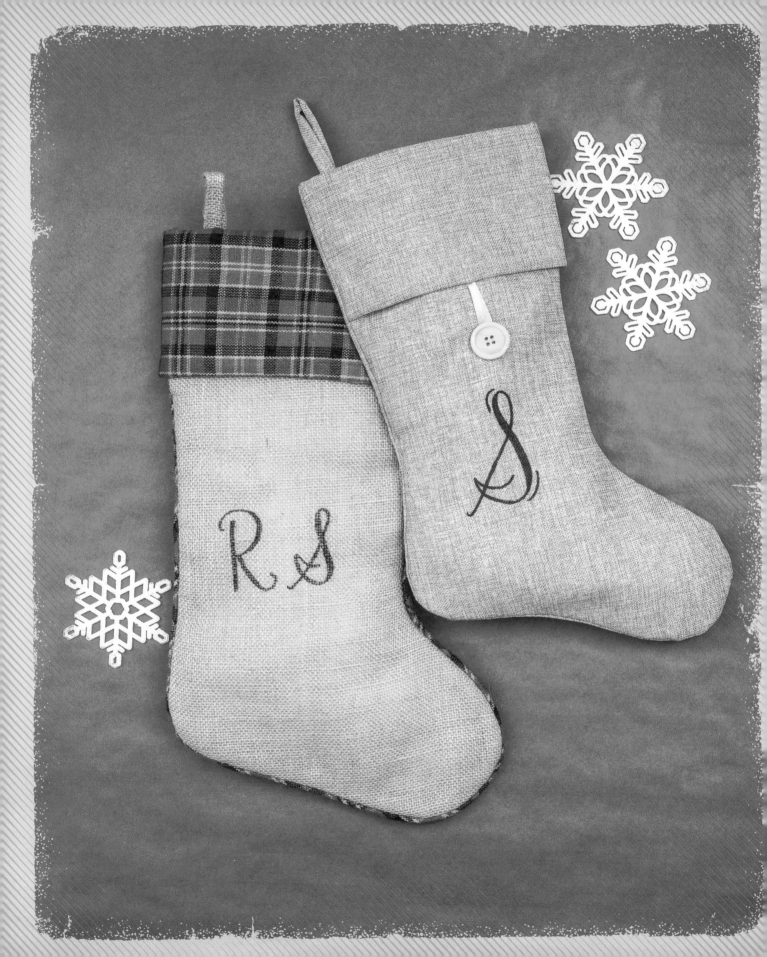

Noel Garland

By Hazel Nguyen

Here's a fun garland that can be used for any occasion! You can also personalize this project for any party this year by choosing your own saying. This design uses a black and gold color scheme. (Trust me, it's always a good idea.)

WHAT YOU'LL NEED:

- Printer paper
- Pencil and eraser
- Scissors
- Black card stock
- ⅛-inch (3 mm) hole punch
- Twine, ribbon, or metallic cording
- Gold metallic paint pen

WHAT YOU'LL DO:

1. With a pencil, sketch a long triangle onto a sheet of printer paper and cut it out to create a stencil. You can use a thicker paper such as card stock to make the stencil if the printer paper is too flimsy.

2. Place your stencil on card stock and trace the triangle shape onto the sheet four times. If you've chosen your own phrase, the number of triangles you make should equal the number of letters in your words. It's also a good idea to make a few extra triangles in case you make errors. When you're done tracing, cut the triangles out.

3. Use your pencil to lightly sketch each letter onto the triangles {A}.

4. You will now thicken the downstrokes of each letter. First, determine the downstrokes for each letter. In the letter *N* for example, the downstrokes are the two vertical lines. Then, draw a line parallel to each downstroke {B}. You can also round off the entrance strokes and the tails of each letter as I did here.

5. Using your gold metallic paint pen, fill in the spaces between the downstrokes {C}. Some paint pens may leak or splatter some ink while it's being used. Don't worry if it happens to you. It will give your banner more character.

6. Add decorative elements to each letter. Here, I added some confetti-like dots on the bottom of each triangle, concentrating more dots on the bottom and spreading them farther apart as I reached the middle. Unleash your creative side and have fun with it!

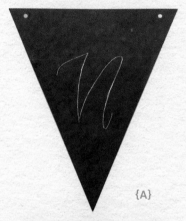

{A}

{B}

{C}

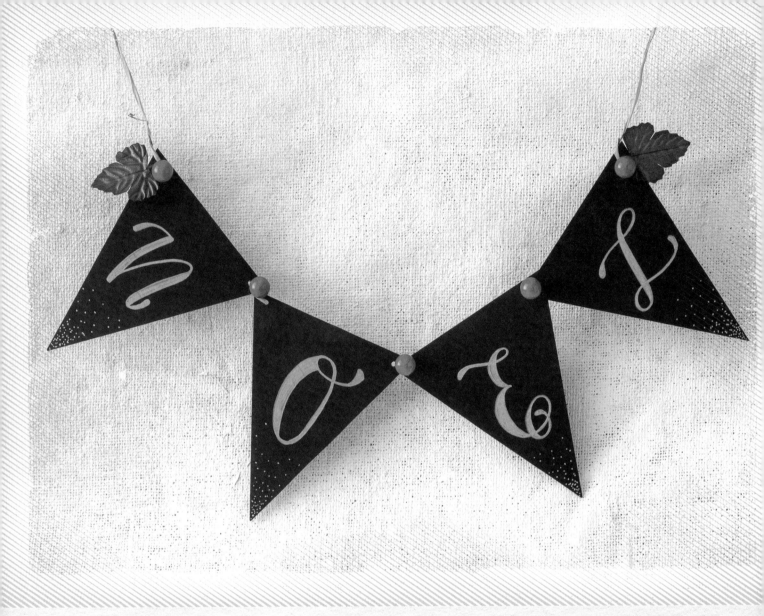

7. Use the hole punch to create holes at the top two corners on each triangle. Place your letters in order {D}. Thread twine through the holes of each triangle, starting with the first triangle in your arrangement. Make sure to leave plenty of twine at the start and end of your garland.

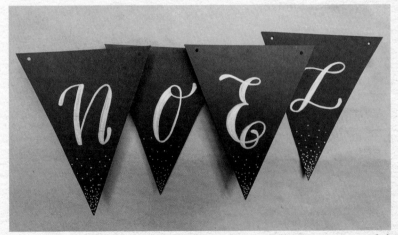

{D}

Holiday Hand Lettering

Hand-Addressed Envelopes

By Shelly Kim

Let's get ready for the holiday season by addressing envelopes in this fun, personalized way! These envelopes are perfect for sending your cards to family and friends. Here, we'll be using a mixture of all caps and script lettering.

{A}

WHAT YOU'LL NEED:

- Ruler
- Pencil and eraser
- Envelopes
- Brush pen in any color
- Fine-tip pen

WHAT YOU'LL DO:

1. Using the ruler, pencil, and eraser, draw a few lines on the envelopes to create guidelines for your lettering. In the example here, there are a total of four horizontal lines. You want to vary the space between the lines, leaving the biggest space between the two centermost lines. You will place the last name in the biggest space, while the first name and address will be written in the smaller ones.

2. Using the brush pen, letter the last name of your recipient in large script letters on the center of the envelope {A}. The goal is to make the last name appear as the most prominent word on the envelope.

3. Using the fine-tip pen and the pencil guidelines, hand-letter the first name in a sans serif font above the last name. In the same sans serif font, write the recipient's address below the last name {B}. Erase the pencil lines.

4. Explore the other designs in {C} and {D}, and have fun with it! To create the design in {C}, just follow the process in steps 1–4 with some adjustments. Here, I changed it up by making the first name instead of the last name appear the largest and placing it the upper left-hand corner of the envelope. Draw a banner similar to the one in the Let It Snow project (page 18),

then hand-letter the last name using a non-script font in all caps. The address appears on the bottom right-hand corner. To create the design in {D}, hand-letter the first name using a script font. Underneath the first name, hand-letter the last name using a non-script font in all caps, placing the letters slightly further to the right than the first name. Feel free to add two dots on each side of the last name. Finish by adding the address on the lower right section of the envelope.

5. On each envelope flap, write the sender's address in the same sans serif font used for the font of the other envelope.

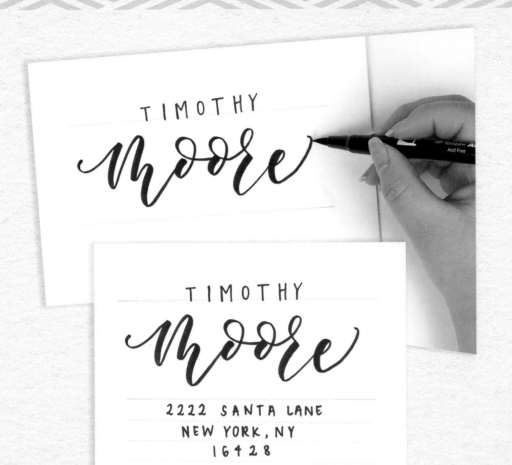

TIMOTHY
Moore

TIMOTHY
Moore

2222 SANTA LANE
NEW YORK, NY
16428

{B}

Rich
LEWIS

5010 TIMES LN.
LOS ANGELES, CA
90042

{C}

Sam
·SMITH·

121 E 68TH ST.
NEW YORK, NY
11220

{D}

New Year's Corkboard Coasters

By Shelly Kim

For New Year celebrations, I love to make custom coasters with motivational words that will help me during the next year. This set of four coasters are an excellent addition to a New Year's party or your office, and make a wonderful gift to give to your friends and family!

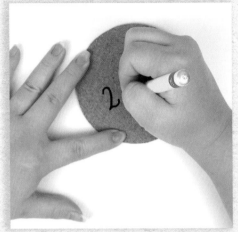
{A}

WHAT YOU'LL NEED:

- Paint markers in colors of your choice
- Corkboard circles

WHAT YOU'LL DO:

1. You can use the designs that I've created, or sketch the designs that you would like in the practice space for this project or on another sheet of paper. There are also traceable versions of my designs on the practice space. The steps below will teach you how to draw my designs onto your coasters.

2. Using a paint marker, write the numbers *2020* (or the numbers corresponding to the year that you're welcoming). For a finishing touch, draw some dots to the left and right of the numbers {A}.

 > *Tip* You can draw light pencil marks to sketch out a guide for your designs. The pencil marks might still show if you use white paint markers, but you can add a few more coats to make the paint more opaque.

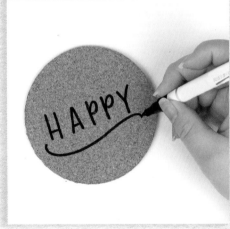
{B}

3. On another corkboard coaster, hand-letter the word *happy* in capital letters with the paint marker using a non-script font. Complete the piece by adding some fun flourishes {B}.

4. For the next coaster, hand-letter the word *cheers* with the paint marker using a script font. Thicken the downstrokes to achieve a faux calligraphy look {C}.

5. For the last coaster, hand-letter the word *dream* with the paint marker using a script font, and you are all set!

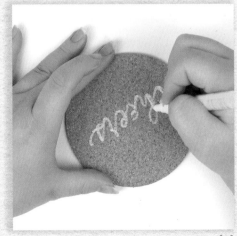
{C}

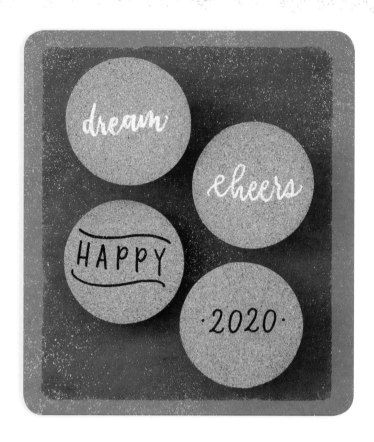

cheers

HAPPY

dream

2020

Happy Holidays Gift Bag

By Hazel Nguyen

Do you find yourself reaching for a plain gift bag more than wrapping paper these days? Do you feel a little guilty because it seems like you didn't put much effort into gift wrapping? No worries! I got you! You can make anyone feel extra special with a personalized gift bag. This project can take anywhere from 5 to 15 minutes, depending on how detailed you want your final design. Using a chalk pencil is also a game changer. It's easy to use, and you don't have to worry about pencil lines showing through since the pigment is already white.

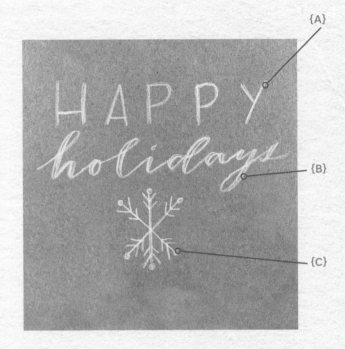

WHAT YOU'LL NEED:

- Chalk pencil
- Paper gift bags
- White paint pen
- Eraser

WHAT YOU'LL DO:

1. With your chalk pencil, sketch out the design on the bag on the center of the bag. Draw *happy* in all uppercase letters and *holidays* in lowercase script {A}.

2. For *holidays*, you may choose to leave them as is or use faux calligraphy and thicken your downstrokes for each letter {B}. I decided to thicken my downstrokes for the word *holidays* to vary the design's fonts.

3. Add a holiday-themed illustration, such as a snowflake, below the phrase to finish the design. When drawing a snowflake, I find that it's easiest to make an *X*, then draw a vertical line right in the middle of the *X* to create six small "stems." Add small "v"-shaped lines at the end of each stem {C}.

4. Once you are happy with your sketch, trace your design with the paint pen {D}. Let the paint dry, erase any leftover sketch marks, and you'll be ready to add your gifts!

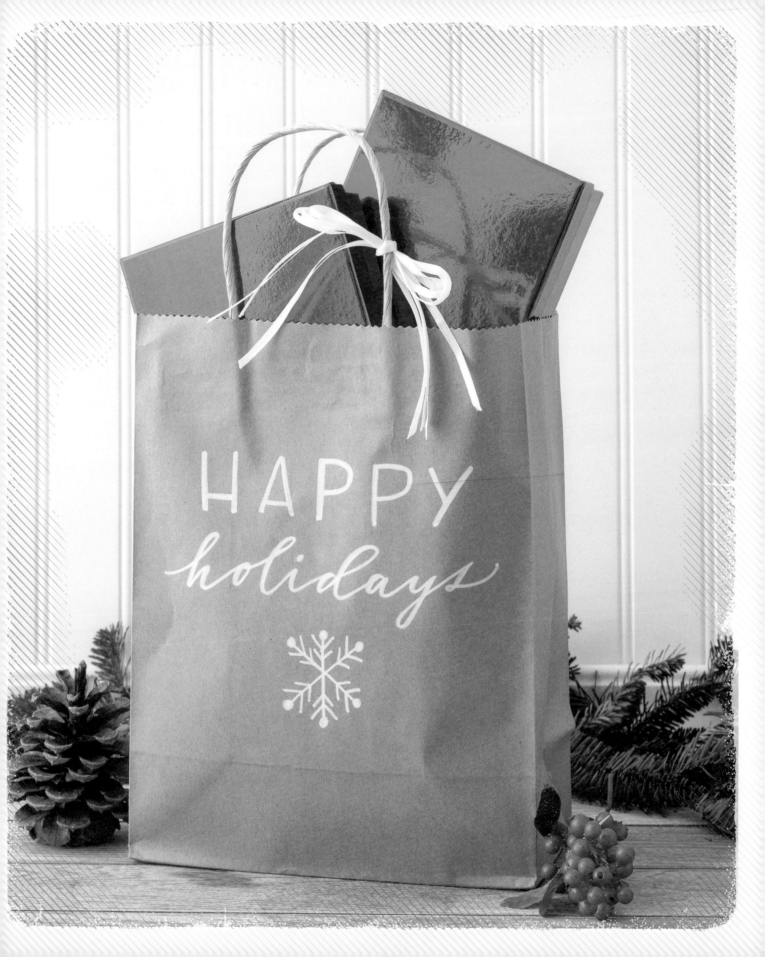

DIY Gift Tags

By Veronica Ruiz

The gift tag is the first thing someone sees when they open their gift, so make your gift boxes, bags, or baked goods stand out with a handwritten gift tag. Adding a personalized touch makes it extra special. You can use bold block letters, beautiful script, or a combination of both! Use glitter gel pens in some reds, greens, and blues to add an extra pop of fun.

WHAT YOU'LL NEED:

- Pencil and eraser
- Kraft paper gift tags
- Black extra fine-tip marker
- Glitter gel pens
- Scissors
- Ruler
- Twine

WHAT YOU'LL DO:

1. With your pencil, draw out all of your designs on the tags. All of your wording will be in monoline at first, so don't worry about thickening any parts yet. Remember to use block letters, script, or a combination of both to add some variety to your tags.

 Tip To trace the designs on page 97, use a pencil and copy the designs you wish to use onto tracing paper. Transfer designs onto your tags using the method outlined on page 8.

2. You will now thicken the downstrokes for both your block and script letters. To do so, add a line parallel to every downstroke using pencil. There is no standard amount of space to leave in between the lines, but because your tags are small, I recommend making a thin space.

3. Use your black marker to ink your pencil lines. Once your marker dries, erase your pencil lines.

4. Fill in your downstrokes. You can use your black marker, if you want a more elegant letter. But using glitter gel pens are a great way to add beautiful pops of color to your tags. If you know the recipient's favorite color, make sure to use it for an added personal touch.

5. To add even more detail, you can add shadows using your gel pens, pencil, or marker. To do this, simply add a line to the right of every vertical stroke or underneath any horizontal stroke. The white shadows are used with **Merry Christmas**, **With Love**, and *Baked With Love*.

6. Set your tags aside to let the marker and gel pen dry. With scissors, cut 8-inch (20.3 cm) pieces of twine to string through your tags. When adding the tags to your gifts, you can tie them to bags, wrap them in ribbon, or attach them with Christmas washi tape.

 Tip Using kraft gift tags, instead of white gift tags, gives you the chance to use a white gel pen. White adds an even brighter pop of color and allows you to make fun snow-themed details.

Baked WITH Love

With Love,

HO HO HO

DON'T OPEN UNTIL X-MAS!

To:

Love,

Merry Christmas

SPECIAL DELIVERY

Warm WISHES

PRACTICE

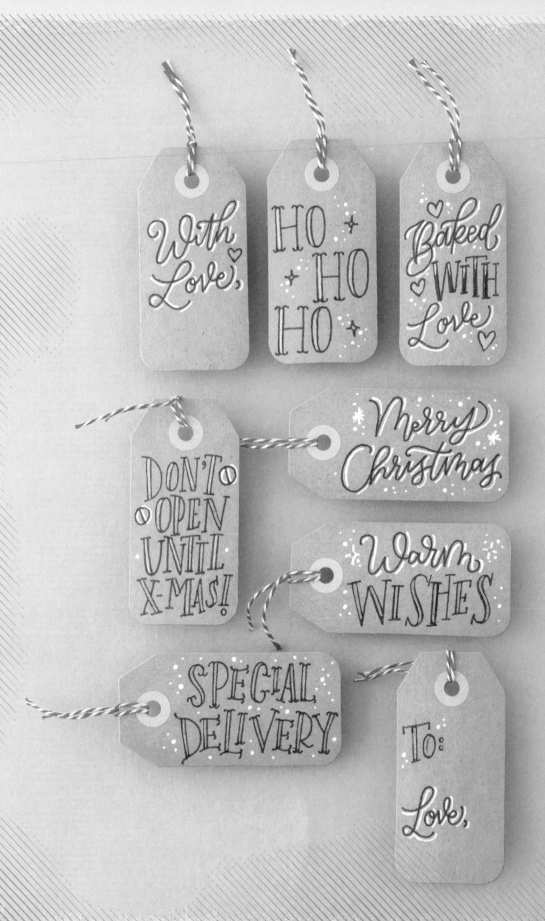

Christmas Tree Ornaments

By Shelly Kim

During the holidays, I absolutely love making personalized ornaments for friends and family. Whether it's a small quote, first name, or inspirational words, I find it a perfect project for this time of year!

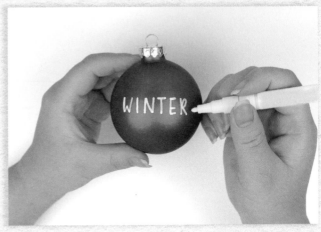

{A}

WHAT YOU'LL NEED:

- Round Christmas ornaments in colors of your choice
- Paint markers in colors of your choice
- Ribbon

WHAT YOU'LL DO:

1. Hand-letter one word or phrase on each ornament using a paint marker {A}. In this example, I chose the year *2020*, *winter*, *hope*, and *star (see page 102 for traceable versions)*.

2. To embellish the words, add a few lines above and below your words as I have done with *winter* {B}.

3. Thicken the downstrokes of each letter {C}. This step creates faux calligraphy, which creates letters that look like calligraphy without using a brush pen.

4. To make the words pop, add a few lines varying in length at the corner of the design {D}.

5. Let the ornaments dry. This usually takes about 20–30 minutes. Then cut a piece of ribbon for each ornament. I cut mine about 7 inches (17.8 cm) long to make the perfect knot. If the length is too long, you can always cut it shorter. Loop it through the ring at the top of the ornaments {E}. You can now gift the ornaments or hang them on your Christmas tree!

{B}

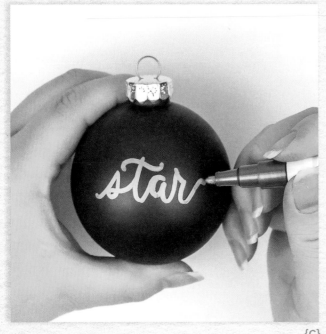

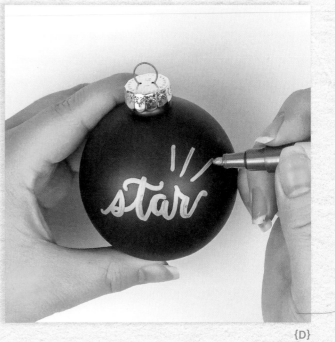

{C} {D}

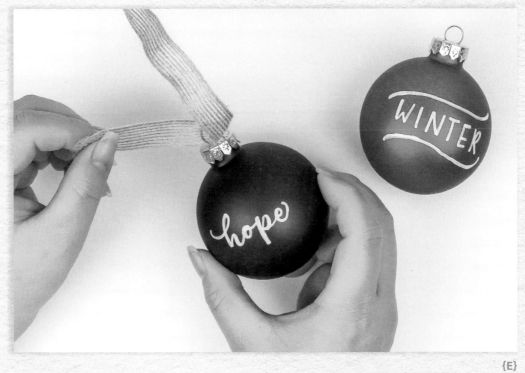

{E}

winter

star

hope

2020

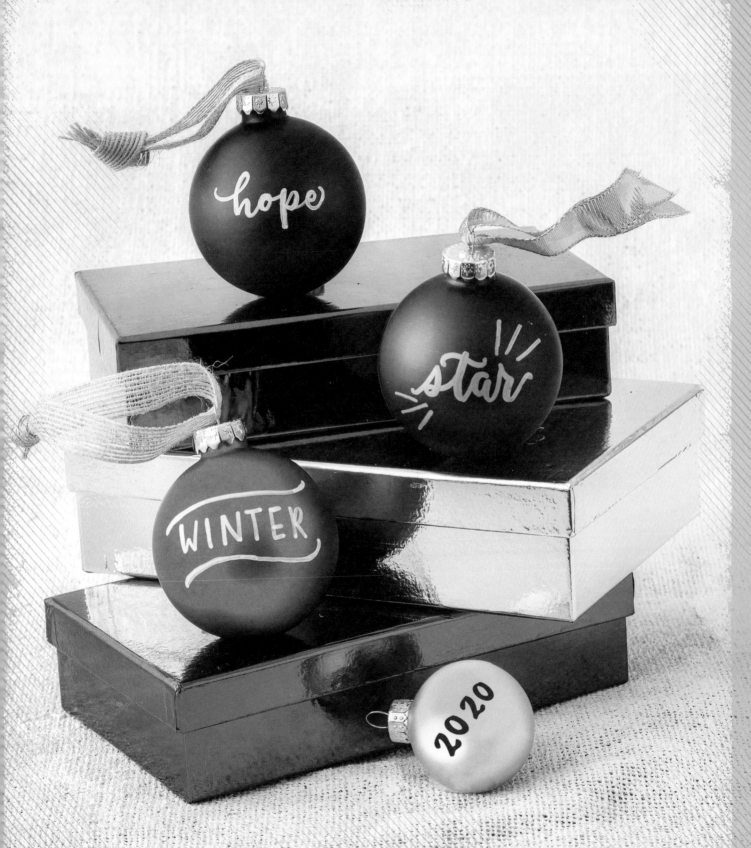

Chalkboard Wood Ornaments

By Veronica Ruiz

Painted wood ornaments can be an excellent addition to your tree. They also make great gifts because they are lightweight and easy to ship. Adding a playful lettering style helps them stand out even more. This mix of script and block lettering is fun to create and easy to customize.

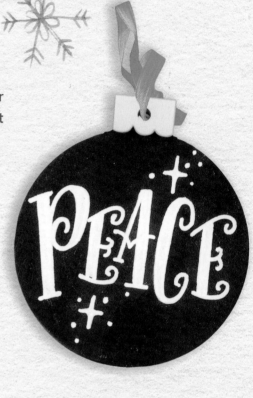

WHAT YOU'LL NEED:

- Round unfinished wood ornaments
- Black chalkboard paint
- Foam brush
- Pencil and eraser
- White fine-tip chalk marker

WHAT YOU'LL DO:

1. Paint your wood ornaments with the black chalkboard paint. Set aside to dry.

2. With your pencil, draw out the words that you'd like to use. To re-create the combination of script and block lettering styles here, draw your block letters, then extend the ends of your letters and curl the ends inwards. The curly ends give your letters a script-like look without needing to create script letters.

Tip To trace the designs on page 105, use a pencil and copy the designs you wish to use onto the tracing paper. Transfer designs onto your ornaments using the method outlined on page 8.

3. Thicken your downstrokes. With your pencil, add a line parallel to the downstrokes in your letters. Because wood ornaments tend to have large spaces to fill, leave a large space in between the lines.

4. Draw over your pencil lines with your chalk marker.

5. Erase any pencil lines that may be showing.

Tip If your chalk marker lines seem too light or your pencil lines are visible, wait for the ink to dry and draw over them again. Some chalk marker inks need to be applied in layers. Remember to cap, shake, and quickly tap the tip on a sheet of scrap paper a few times. This ensures that the ink flowing to the tip is fresh.

Joy

Love

Merry

Nice

Noel

Naughty

25

Peace

PEACE

Merry

JOY

NOEL

25

NICE

LOVE

Nau ghty

Hand-Lettered Mug

By Shelly Kim

There's something about hand-lettered custom mugs that excites me. Here you will be making a customized holiday-edition mug. As a gift, it pairs perfectly with some hot cocoa mix. Because you'll create the design with markers, I recommend only hand-washing this item; a dishwasher may ruin the design.

WHAT YOU'LL NEED:

- Ceramic mug
- Cotton pads or cotton balls
- Rubbing alcohol
- Pencil and eraser
- Oil-based paint markers

WHAT YOU'LL DO:

1. Before starting the hand-lettering process, clean the surface you will be lettering using the cotton pads and rubbing alcohol {A}. This will remove any excess dust so the paint markers glide smoothly on the mug.

2. Using your pencil and eraser, create a sketch of the overall piece on the practice page (page 110) or a separate piece of scrap paper. Consider the spacing and composition while you draw your letters. In this example, I used the words *ho ho ho*.

3. Using the paint markers, hand-letter the piece in any font you choose, working one word at a time {B}. A script font and an uppercase sans serif font are used for this example. For the second word, you can draw some lines above and below the word to separate the text {C}.

4. Feel free to thicken the upstrokes for a bold look {D}.

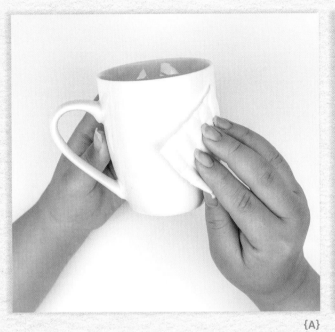

{A}

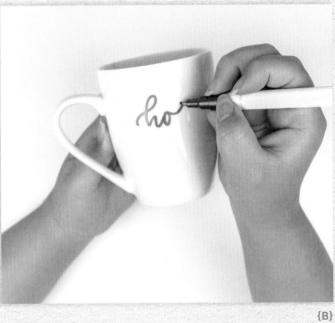

{B}

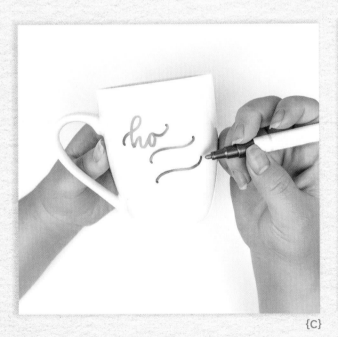

{C}

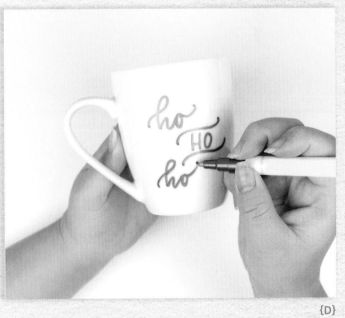

{D}

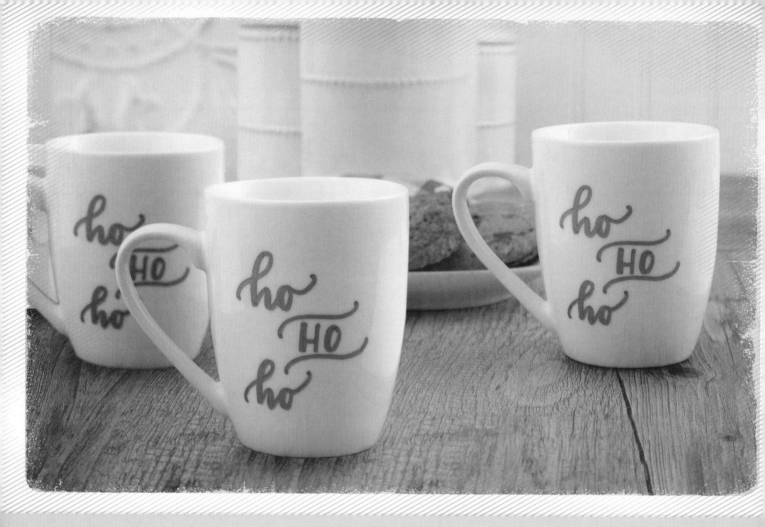

PRACTICE

'Tis the Season To Be Jolly Sign

By Veronica Ruiz

This jolly saying is perfect for a chalkboard sign that hangs on your door, waiting to greet your guests! But, if you have a beautiful wreath on your door, this sign will look just as gorgeous on the inside of your home! When sketching on a black chalkboard surface, pencil can be a little difficult to see. The sketches provided were completed on a white sheet of paper to make it easier to follow, but all of the sketches for the final piece were drawn on the chalkboard itself.

WHAT YOU'LL NEED:

- Pencil and eraser
- Chalkboard sign, 10 x 8 inches (25.4 x 20.3 cm)
- White, green, gold, and red liquid chalk markers

WHAT YOU'LL DO:

1. Using your pencil, sketch out every section of the quote on your chalkboard. First, draw the banner (see page 16 for a quick tutorial), then add *'Tis the* inside the banner. Sketch the remaining words in varying sizes, using a mix of block and script styles {A}. Big, bold block letters are perfect for words you want to emphasize, like the word *season* in this piece. Script works well for words that need to fit in small and narrow spaces, like *'Tis the*, and ones that you want to showcase, like *jolly*. I chose to draw to be in block letters to balance out the *jolly* to the right.

2. Refine your sketch by erasing any extra strokes you don't want to cover with your chalk markers. It's important to erase any pencil lines before you apply the liquid chalk because it's difficult to remove them once it's covered with ink. Add details to your letters, such as the candy-cane stripes in the word *season*. You can add serifs, like the ones in *season*, and any decorative doodles, like the snow dots and stars around the banner {B}.

3. Trace your sketch with the liquid chalk markers. Choose colors that match your Christmas color scheme! Green, red, white, and gold are a great combination for a traditional look. Or you can experiment with something frostier by using blues, white, and silver.

 Chalk markers are not permanent, so if you make a mistake, erase and refine that section instead of wiping away the entire piece.

{A}

{B}

PRACTICE

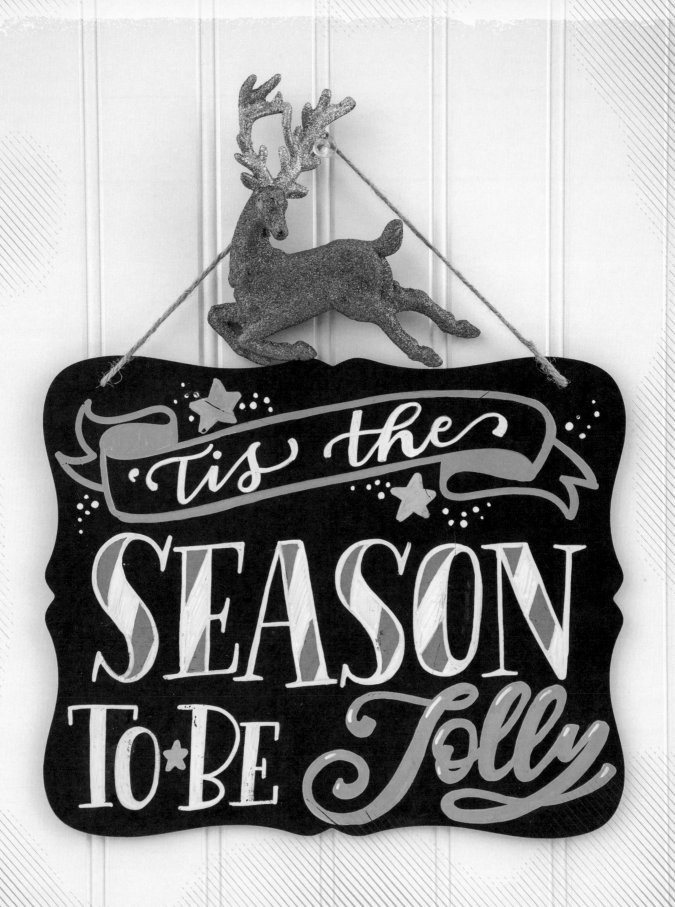

ALPHABETS

BELLE ROSE SCRIPT By Hazel Nguyen

This sweet yet simple modern calligraphy script has a delicate touch that works well for a wide range of projects. This is my go-to script and what I feel most comfortable using. It's perfect for all skill levels.

A a B b C c D d

E e F f G g H h

I i J j K k L l

M m N n O o P p

Q q R r S s T t

U u V v W w X x

Y y Z z

CANDY CANE LANE ALPHABET **By Veronica Ruiz**

This alphabet is inspired by the yummiest treat for the holidays. Candy canes are all sorts of fun to eat and decorate your tree with. So why not decorate your letters like them too?

Aa Bb Cc Dd
Ee Ff Gg Hh
Ii Jj Kk Ll
Mm Nn Oo Pp
Qq Rr Ss Tt
Uu Vv Ww
Xx Yy Zz

Tip

After you color in your red stripes, add a highlight line to your letters using a white gel pen. This will add more dimension to your letters.

CURLY SCRIPT By Shelly Kim

This alphabet brings back my love for cursive from elementary school. I wanted this style to have fun, loose loops with the look of calligraphy. You'll find thick lines for the downstrokes and thin lines for the upstrokes.

Aa Bb Cc Dd Ee

Ff Gg Hh Ii Jj

Kk Ll Mm

Nn Oo Pp Qq

Rr Ss Tt Uu

Vv Ww Xx Yy Zz

KRINGLE By Winterbird

Kringle is a brush-lettering alphabet with high contrast and cute swirls. You can make these letters with a brush pen or with a fine line pen. Try adding additional flourishes to the swirls of a letter for a fancy look.

Aa Bb Cc Dd

Ee Ff Gg Hh

Ii Jj Kk Ll Mm

Nn Oo Pp Qq

Rr Ss Tt Uu Vv

Ww Xx Yy Zz

This geometric typeface is playful and clean and has a rounded shape. Its minimalist feel is ideal for headers or messages written entirely in capital letters.

Aa Bb Cc Dd
Ee Ff Gg Hh
Ii Jj Kk Ll
Mm Nn Oo Pp
Qq Rr Ss Tt
Uu Vv Ww Xx
Yy Zz

OLD-TIME ALPHABET By Marie Hermansson

This alphabet is reminiscent of vintage lettering you would have seen on holiday cards around Victorian times. It has fun decorative serifs that give each letter an ornate look. Try changing the widths of the serifs to mix up the look of your letters.

Aa Bb Cc Dd
Ee Ff Gg Hh
Ii Jj Kk Ll
Mm Nn Oo
Pp Qq Rr Ss
Tt Uu Vv Ww
Xx Yy Zz

OUTLINEDER By Colleen Wilcox

When I started hand-lettering, I used all different kinds of typography as inspiration. It took me a while to cultivate a style of my own, but I found myself using these tall, skinny outlined letters for much of my work and loved the way they stood out. This alphabet looks great in black and white, but it's also quite easy to add color to by filling the letters in with markers! All you need to create it is a fine-tip pen.

Aa Bb Cc Dd Ee

Ff Gg Hh Ii Jj Kk

Ll Mm Nn Oo Pp

Qq Rr Ss Tt Uu

Vv Ww Xx Yy Zz

Tip To draw the lowercase letters with cursive-like elements, it helps to sketch the letters in pencil first and then outline them with your pen. Erase the pencil lines when you're done.

Tip Try to keep the pressure on your writing tool consistent to keep the weight of the lines even.

ROUND LETTERS By Shelly Kim

I created this sans serif alphabet so that you can pair it with other styles and still create a piece with a simple look. I absolutely love the simplicity of these capital letters and the style of the downstrokes.

Aa Bb Cc Dd Ee Ff

Gg Hh Ii Jj Kk Ll

Mm Nn Oo Pp Qq Rr

Ss Tt Uu Vv Ww

Xx Yy Zz

SHAPELY By Colleen Wilcox

This alphabet emulates the unique letterforms I make in my artwork. Much of my hand-lettering involves filling a shape with words. I love the challenge of using letters and negative space. You can elongate and shrink these letters to fit them where you want to in your design.

This alphabet has a playful and lopsided look that will be perfect for some of your projects.

Aa Bb Cc Dd Ee
Ff Gg Hh Ii Jj Kk
Ll Mm Nn Oo Pp
Qq Rr Ss Tt Uu
Vv Ww Xx Yy Zz

Tip Remember, symmetry is not important for these letters! Play with stretching and expanding your lines beyond the baseline and cap line.

Tip Use a thicker marker to create these letterforms.

SWIRLY SKATES ALPHABET By Veronica Ruiz

Aa Bb Cc Dd

Ee Ff Gg Hh

Ii Jj Kk Ll

Mm Nn Oo

Pp Qq Rr Ss

Tt Uu Vv Ww

Xx Yy Zz

This alphabet is inspired by the wonderful swirls left behind after an ice skater dances on the ice. To replicate the thin upstrokes and thick downstrokes of this alphabet, you'll need to use a brush pen and vary the pressure you're using with it.

ABOUT THE CONTRIBUTORS

Marie Hermansson is a freelance illustrator and designer. Her work combines her love of lettering, illustration, color, and pattern. She happily spends her time drawing, illustrating and raising her two small children in North Carolina. To view more of Marie's art, visit her website MarieHermanssonIllustration.com and follow her on Instagram (@MarieHermanssonIllustration), where she posts new work weekly.

Shelly Kim, also known as Letters By Shells, is a self-taught modern brush calligrapher based in Southern California. She loves to explore different mediums to create her artwork. She has collaborated with companies including Apple, Adobe, MOO, Ranger Ink, Tombow, and Mixbook and has been featured on CBS News and Art Insider. Shelly's journey started when she was unhappy at her full-time job and needed another outlet to relieve stress. As she continues to explore lettering, she hopes to use this art form to spread more positivity to others and remind them that they are capable of pursuing anything in life. You can see more of her work at lettersbyshells.com and on Facebook and Instagram (@lettersbyshells).

Hazel Nguyen is a SoCal-based artist and a lover of all things lettering, arts, and crafts. Always aspiring to inspire others, she is a strong believer of spreading positivity through her creation and life in general while having some fun along the way. You can find her on Instagram (@hazelslettering).

Veronica Ruiz is a lettering artist based in Denver, Colorado. Drawing letters has been her passion since she was first exposed to the wonder of typography in her graphic design classes at the University of Central Florida. Veronica loves sharing everything she's learned in her lettering journey with others through her Instagram (@veronicaletters) and her blog at veronicaletters.com.

Colleen Wilcox is an artist and the founder of Wander On Words, a small business focused on hand lettering. She uses her lettering to create inspirational designs with words and transforms them into cards, prints, and apparel. Colleen strives to be constantly creating in order to inspire, motivate, spread positivity, and rekindle a love for the wilderness in others. You can check out Wander On Words at wanderonwords.com and follow Colleen's adventures on Instagram and Facebook (@wanderonwords).

Winterbird has ten years of experience in the field of graphic arts. Her passion and focus is calligraphy, and she loves inspiring others to find their creativity. Winterbird is from Norway where she achieved the title of Master Craftsman in Graphic Design. Currently, she resides in the United States with her family. You can find her on Instagram (@Winterbird), where she posts modern calligraphy art every day. You can also visit winterbird.com for her lettering and calligraphy guides.

INDEX

Note Page numbers in *italics* indicate projects.